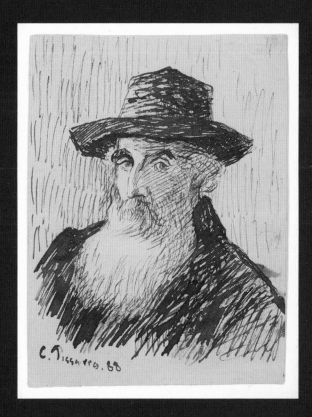

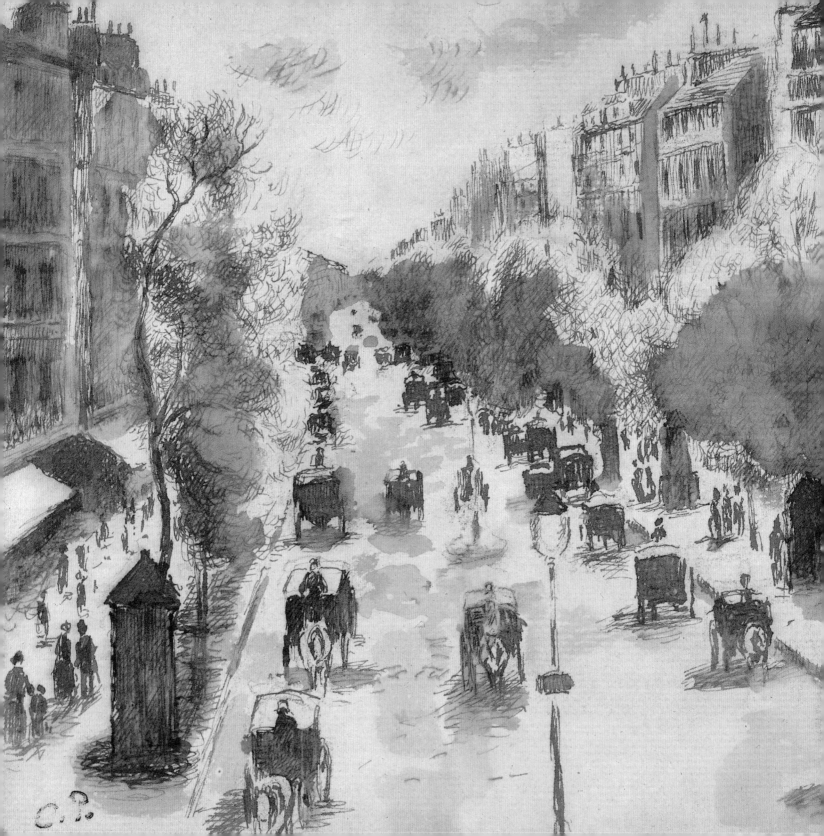

C. P.

Camille Pissarro
Impressions of City & Country

Karen Levitov and Richard Shiff

THE JEWISH MUSEUM, NEW YORK

UNDER THE AUSPICES OF THE JEWISH THEOLOGICAL SEMINARY OF AMERICA

YALE UNIVERSITY PRESS

NEW HAVEN AND LONDON

This book has been published in conjunction with the exhibition
Camille Pissarro: Impressions of City and Country,
organized by The Jewish Museum and presented from September 16, 2007, to February 3, 2008.

Published by The Jewish Museum, New York
Distributed by Yale University Press, New Haven and London

The Jewish Museum
Exhibition Curator: Karen Levitov
Manager of Curatorial Publications: Michael Sittenfeld
Curatorial Program Assistant: Emily Casden
Manuscript Editor: Stephanie Emerson
Exhibition Design: Daniel Bradley Kershaw
Exhibition Graphic Design: Daria Kissenberth

Designed by Steven Schoenfelder
Typeset in Bernhard Modern and Centaur
Printed in Italy by Graphicom S.r.l.

The Jewish Museum
1109 Fifth Avenue, New York, New York 10128
www.thejewishmuseum.org

Yale University Press
P.O. Box 209040, New Haven, Connecticut 06520-9040
www.yalebooks.com

Library of Congress Cataloging-in-Publication Data
Levitov, Karen.
Camille Pissarro : impressions of city and country / Karen Levitov and Richard Shiff.
p. cm.
Issued in connection with an exhibition held Sept. 16, 2007–Feb. 3, 2008, Jewish Museum, New York.
Includes bibliographical references and index.
ISBN 978-0-300-12479-8 (pbk.: alk. paper)
1. Pissarro, Camille, 1830–1903—Exhibitions. 2. Landscape in art—Exhibitions. 3. Cities and
towns in art—Exhibitions. I. Shiff, Richard. II. Pissarro, Camille, 1830–1903.
III. Jewish Museum (New York, N.Y.) IV. Title.
ND553.P55A4 2007
759.4—dc22
[B]
2007017134
A catalogue record for this book is available from the British Library.

The paper in this book meets the guidelines for permanence and durability of the Committee
on Production Guidelines for Book Longevity of the Council on Library Resources.

10 9 8 7 6 5 4 3 2 1

Page i: **Self-Portrait**, 1888. Pen and ink on paper, 6¾ x 5⅛ in. (17.4 x 13 cm).
Samuel Putnam Avery Collection, Miriam and Ira D. Wallach Division of Art, Prints and Photographs,
The New York Public Library, Astor, Lenox and Tilden Foundations
Pages ii–iii: **Carriages on the Boulevard Montmartre**, 1897 (detail of pl. 43)
Cover illustrations: front, **The Pont-Royal, Bright Cloudy Weather (Fourth Series)**, 1903
(detail of pl. 49); back, **Picking Peas**, 1887 (detail of pl. 29)

Contents

DONORS TO THE EXHIBITION—VI

LENDERS TO THE EXHIBITION—VII

ACKNOWLEDGMENTS—VIII

PATHS TO PISSARRO—I

Karen Levitov

PISSARRO:
DIRTY PAINTER—15

Richard Shiff

PLATES—30

EXHIBITION CHECKLIST—78

NOTES—80

INDEX—83

ILLUSTRATION CREDITS—85

THE JEWISH MUSEUM BOARD OF

TRUSTEES—86

Donors to the Exhibition

CAMILLE PISSARRO: IMPRESSIONS

OF CITY AND COUNTRY

IS SPONSORED, IN PART,

BY TOLL BROTHERS, INC., AND

THE GRAND MARNIER FOUNDATION.

IMPORTANT SUPPORT WAS

ALSO PROVIDED BY

THE MAILMAN FOUNDATION, INC.,

AND OTHER GENEROUS DONORS.

Lenders to the Exhibition

Albright-Knox Art Gallery, Buffalo, New York

Armand Hammer Foundation

The Art Collection, Inc., Great Neck, New York

Brooklyn Museum

The Hyde Collection, Glens Falls, New York

The Metropolitan Museum of Art, New York

The Pierpont Morgan Library and Museum, New York

The New York Public Library

Francis Belmont

Bettina L. Decker

Simone and Alan Hartman

Deanne and Arthur Indursky

Michael and Henry Jaglom

Mr. and Mrs. Herbert Klapper

Barbara and Harvey Manes

Mr. and Mrs. Jeffrey Peek

Private collections

Margaret and Adrian Selby

Jeffrey Steiner

Bruce and Robbi Toll

John C. Whitehead

Mr. and Mrs. Joseph Wilf

Acknowledgments

A founding member of the Impressionists, Camille Pissarro (1830–1903) was the only artist to show his paintings in all eight of the Impressionist exhibitions from 1874 to 1886. Born in the Danish Virgin Islands, Pissarro lived in Venezuela for two years before settling permanently in France. Throughout his long career, he lived and worked in various villages in the French countryside and spent much time in Paris, and traveled to England, Belgium, and the Netherlands as well.

Although he never voyaged to the United States, Pissarro's works were exhibited here as early as 1883 and American collectors began buying his works during the artist's lifetime. Today some of the greatest Pissarro paintings are in American collections, with a large number in public and private collections in the New York area. This exhibition brings together nearly fifty paintings and works on paper, drawn primarily from private collections in the New York area, many of which have rarely been on public view. My deepest gratitude goes to the private lenders listed on page vii, whose generous participation made this exhibition possible. I would also like to thank their assistants who facilitated these loans.

Several institutions kindly lent work to the exhibition and their support is greatly appreciated. Many thanks to Louis Grachos, Director, Albright-Knox Art Gallery, Buffalo; Arnold Lehman, Director, and Judith F. Dolkart, Associate Curator, the Brooklyn Museum; Randall Suffolk, Director, The Hyde Collection, Glens Falls, New York; Philippe de Montebello, Director, The Metropolitan Museum of Art; Charles E. Pierce, Jr., Director, The Morgan Library and Museum; and Paul LeClerc, President and CEO, and Roberta Waddell,

Curator of Prints, The New York Public Library. We also greatly appreciate the work of the registrars, loan officers, and image resource staff at each of these institutions.

Numerous galleries, art dealers and auction houses also lent works, facilitated loans, and provided information. We are indebted to Achim Moeller, Director, Achim Moeller Fine Art, New York, and his assistant Patrick Monahan; Michael Findlay, Director, Acquavella Galleries, New York; Michelle Sakhai, President, The Art Collection, Great Neck, New York; Michael Connors, Director, Michael Connors Antiques, New York; Barbara Divver, Director, and Joy Glass, Manager, Barbara Divver Fine Art, New York; Howard Shaw, Vice-President, Hammer Galleries, New York; and Michael Hammer, Chair of Armand Hammer Foundation and Hammer Galleries, New York; Gregory Hedberg, Director, European Paintings and Sculpture, Hirschl and Adler Galleries, New York; Solange Landau; David Stern, Director, and his assistant Sara Cohen, Stern Pissarro Gallery, London; Joseph Baillo, Senior Vice-President, Wildenstein & Company, New York; and Talma Zakai, Talma Galleries Fine Art, New York. At Sotheby's, New York, David Norman, Executive Vice-President, Impressionist Art, was extremely supportive, as was his assistant Lucinda Ciano. Guy Bennett, Head of the Impressionist Department at Christie's, New York, and his assistant Jessica Fertig were also very helpful.

This exhibition and catalogue greatly benefited from the advice, consultation, and support of members of the extended Pissarro family. Joachim Pissarro, Bershad Professor of Art History at Hunter College and Director of the Hunter College Galleries and Adjunct Curator at the Museum of Modern Art,

provided guidance in the initial stages of this project and continued to lend his expertise throughout its development. I am tremendously grateful for his generous support and enthusiasm for this project. My appreciation also goes to David Stern and Lélia Pissarro and Lionel and Sandrine Pissarro for their helpful assistance in obtaining loans. Pissarro scholar Barbara Stern Shapiro contributed invaluable advice and information.

My deep gratitude goes to Richard Shiff for his illuminating and insightful essay in this volume. Steven Schoenfelder has created a beautiful design for the book, and we are grateful for the exemplary professionalism of our colleagues at Yale University Press, especially Patricia Fidler, Michelle Komie, and Mary Mayer. I also wish to thank Stephanie Emerson for her expert editing of the manuscript.

Claire Durand-Ruel Snollaerts of Wildenstein Institute, Paris, provided the majority of the images for this catalogue. Her generous and efficient assistance greatly contributed to the creation of this publication. Additional images were provided by photographers Richard Goodbody and Wit McKay, Art Resource, the Bridgeman Art Library, and the many institutions listed in the photography credits on page 85.

Our exhibition design team included Dan Kershaw, who created a striking installation for the exhibition, and graphic designer Daria Kissenberth, who produced the graceful signage based on Steven Schoenfelder's elegant design.

In creating its exhibitions, The Jewish Museum relies on the expertise of its staff and the support of its Board Exhibition Committee, Trustees and advisors. I am enormously grateful to Curatorial Program Assistant Emily Casden, whose organizational skills, efficiency, and enthusiastic participation in every aspect of the exhibition and catalogue were integral to their success. Michael Sittenfeld, Manager of Curatorial Publications, oversaw each detail of this publication with the constant attention and steady commitment to excellence we have come to expect from him. Jane Rubin, Director of Collections and Exhibitions, and Julie Maguire, Associate Registrar, handled the myriad details of securing works of art for this exhibition. Special thanks go to Director of Communications Anne Scher, Director of Marketing Grace Rapkin, Director of Operations Al Lazarte, Director of Institutional Giving Sarah Himmelfarb, and their respective staffs, who all contributed to this exhibition's success.

Mounting exhibitions is a costly endeavor and would not be possible without the support of generous donors. We are deeply indebted to Toll Brothers, Inc., The Grand Marnier Foundation, and The Mailman Foundation, Inc. Our Board of Trustees sustains all of us—without its support and commitment The Jewish Museum as we know it would not exist. Finally, I want to express my gratitude to Ruth Beesch, Deputy Director for Program, and Joan Rosenbaum, the Helen Goldsmith Menschel Director of The Jewish Museum, whose intelligence and wisdom have been indispensable to this project.

Karen Levitov
Associate Curator
The Jewish Museum

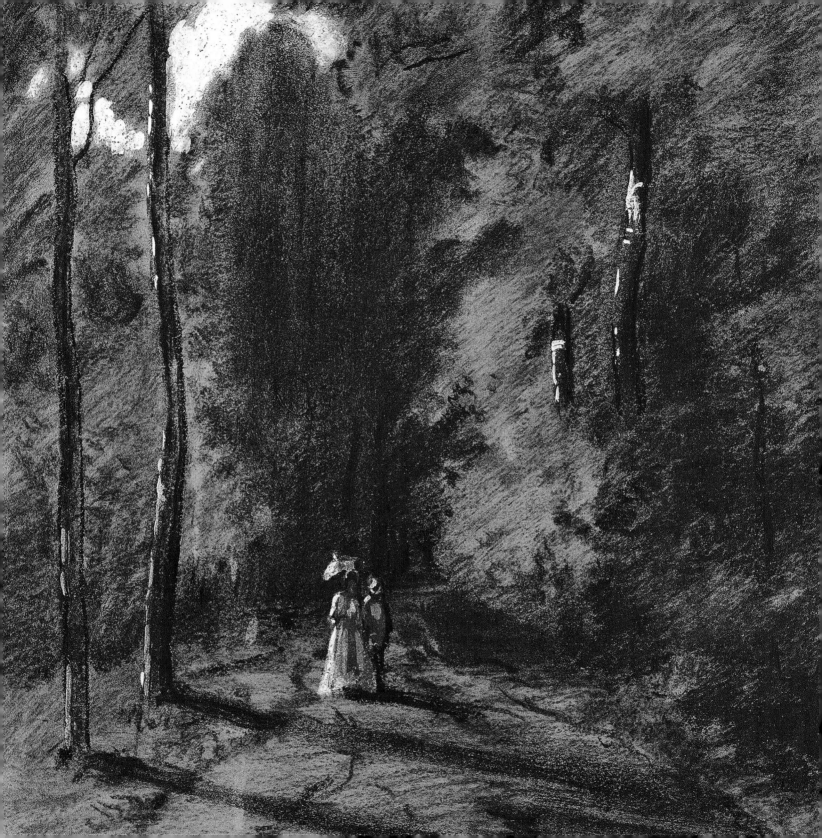

Karen Levitov

PATHS TO PISSARRO

Camille Pissarro is best known for his landscapes painted in and around over a dozen villages in the French countryside where he lived and worked.[1] Late in his career, Pissarro concentrated on urban scenes, painting more cityscapes than any other Impressionist artist, in the port cities of Rouen, Le Havre, and Dieppe, as well as the metropolises of Paris and London. Despite this variety, Pissarro was hardly a constant traveler, and certainly not an itinerant painter. Once settled in a locale, he would remain for significant lengths of time, often over a decade, all the while making frequent trips to Paris. Pissarro's journeys reflect his ceaseless desire to seek out new motifs and explore new ideas in paint.[2]

The path occurs as a frequent motif in Pissarro's work (see fig. 1). From his early sketches in St. Thomas and Venezuela to his late depictions of Paris and London, Pissarro utilized the image of the path both as a compositional element and as an expression of his constantly developing political beliefs and artistic ideas. The path, usually a rough, winding road, connotes both rural labor and leisurely strolls, and calls attention to the intersection of nature and society. It can also been viewed as the literal and figurative connection between the countryside and the city, a route Pissarro traversed countless times. In Pissarro's late cityscapes, the pathway takes the form of the urban street or boulevard, reflecting the social and political environment of the late nineteenth century. The concept of the pathway illuminates Pissarro's approach to art, shedding light on his retreat from conventional aesthetic and political attitudes, the relationship between the work of painting and the labor of the working classes in his work, and the links between his artistic and political ideas.

OPPOSITE PAGE: Detail of pl. 5

Fig. 1. Camille Pissarro (French, 1830–1903) *The Railway Crossing at Les Pâtis, Near Pontoise*, 1873–74 Oil on canvas, 25⅝ × 31⅞ in. (65 × 81 cm) The Phillips Family Collection

Journeys and Explorations

PISSARRO'S ARTISTIC CAREER BEGAN as a voyage. Born in 1830 on the Caribbean island of St. Thomas, then part of the Danish Virgin Islands, Pissarro grew up in a Sephardic Jewish family from France of Portuguese ancestry. Pissarro's father, Frédéric (né Abraham), came to St. Thomas from Bordeaux to look after his late uncle's recently widowed wife, Rachel Manzano-Pomié Petit, and assist her with the family dry goods business on the island. Frédéric eventually fell in love with Rachel and sought to marry her in the St. Thomas synagogue, but religious authorities refused to sanction the union since the couple was related by marriage. Many years and three children later, however, they finally received official recognition.[3] The third of four sons, Pissarro—whose Sephardic name, Jacob Pizarro, appears on his birth certificate—grew up in a bourgeois household though, owing to the lack of acceptance of his parents' marriage, he and his siblings were sent to a Protestant school attended primarily by the children of black slaves. At the age of twelve, he was sent to Paris, where he received both a formal education and training in painting and drawing. Upon his return to St. Thomas six years later, he was expected to work in the family business, but, in an act of defiance, soon left St. Thomas to paint in Venezuela with his friend, the Danish artist Fritz Melbye. A few years later, in 1855, he settled permanently in France, first becoming established in Paris before moving to a series of towns in the rural countryside of the Parisian environs. Despite their initial dismay at their son's decision, his parents eventually followed him to France and supported him financially in his pursuits. Pissarro's rebellious young adulthood signified both a retreat from his parents' bourgeois life and a new approach to his own emerging sense of individualism, which would later characterize his paintings.

Pissarro settled into a city in a moment of transition with Baron Georges-Eugène Haussmann's rebuilding project radically transforming Paris's streets, parks, and public buildings while forcing the working classes out of the center of the city.[4] Pissarro enrolled in private classes at the École des Beaux-Arts and received informal instruction and advice from the renowned landscapist Jean-Baptiste-Camille Corot, whose work he had seen at the Universal Exposition. Corot's impact was substantial; the Barbizon School style embodied by Corot legitimized Pissarro's

interest in landscape, and one of Corot's paintings at the Universal Exposition, *The Cart, Souvenir of Marcoussis, Near Montlhéry* (fig. 2), anticipates Pissarro's later scenes of rural laborers. In a remarkably resonant notebook entry from twenty years before the first Impressionist exhibition, Corot wrote: "Let your feelings be your only guide. . . . Follow your convictions. . . . The beautiful in art is truth, filtered through the impressions we receive as we see nature."[5]

During his early years in Paris, Pissarro continued to depict the Caribbean subjects he had begun painting in St. Thomas. In *Inlet and Sailboat* of 1856 (pl. 2), the shoreline forms a curving pathway on which two isolated figures walk. Though their destination and purpose are unknown, the inclusion of these figures, as well as the boat in the inlet, suggest a journey or passage. Not insignificantly, the figures are Caribbeans of African descent, demonstrating an early interest in the daily lives of non-bourgeois people that would later manifest itself as an affiliation with the working class and laborers of the French countryside.[6]

By the 1860s Pissarro and other modern painters began to explore the regions around Paris made newly accessible by railway. The countryside provided a chance to paint the landscape in *plein-air* and also an opportunity to escape the social and political pressures of Parisian life, including the art establishment embodied by the official Salon. Pissarro initially showed in the Salons, even garnering admiration from the novelist and critic Émile Zola before

Fig. 2. Jean-Baptiste-Camille Corot (French, 1796–1875)
The Cart, Souvenir of Marcoussis, Near Montlhéry, c. 1855
Oil on canvas, 38¼ × 51⅛ in. (97 × 130 cm)
Musée d'Orsay, Paris, France (RF1778)

he was a known artist.[7] However, he eventually refused to show in the Salons, emphasizing his convictions as a stalwart member of the Impressionist group, which avowed independence from established organizations. Artists including Pissarro, Paul Cézanne, Claude Monet, Pierre-Auguste Renoir, and Alfred Sisley, all of whom met in Paris, retreated to the rural villages and farms to find motifs in modern everyday life rather than in the historical and mythological subject matter favored by their predecessors and the judges of the official Salon. These artists all lived in the same region in the country and painted together outdoors, sharing their experiments in light and color. Influenced by the realism of Courbet, Pissarro and others depicted the rural settings, complete with indications of modernity such as

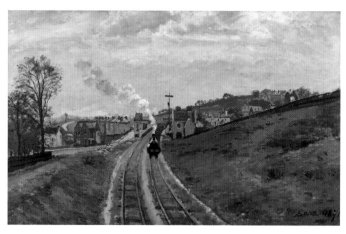

Fig. 3. Camille Pissarro
*The River Oise, Near
Pontoise*, 1873
Oil on canvas, 17⅞ × 21⅝ in.
(45.3 × 55 cm)
The Sterling and Francine
Clark Art Institute,
Williamstown, Massachusetts
(1955.554)

Fig. 4. Camille Pissarro
*Lordship Lane Station,
Dulwich*, 1871
Oil on canvas, 17½ × 28½ in.
(44.5 × 72.5 cm)
The Samuel Courtauld
Trust, Courtauld Institute
Art Gallery, London, United
Kingdom (P.1948.SC.317)

smokestacks and railways (figs. 3, 4). Pissarro, however, was also interested in the utopian, egalitarian implication of living and working in accord with nature. For Pissarro, the country was a means to commune with the rural working class, at least on canvas, and to escape the conventions of metropolitan living.

Approaches and Retreats

PISSARRO BASED HIS APPROACH to art on two concepts mentioned frequently in his correspondence: *nature* and *sensations*. While emphasizing the importance of studying *nature* and faithfully representing the visual world, he believed that nature in art is mediated by *sensations*—those feelings, perceptions, and memories that are personal, subjective, and continuously shifting. He advised his eldest son Lucien, also an artist, to draw from nature but to also "go on with the work from memory" so that "the drawing will have art—it will be your own."[8] Later, he stated that "persistence, will, and *free* sensations are necessary, one must be undetermined by anything but one's own sensation."[9] Pissarro's individualistic viewpoint closely parallels Zola's 1866 statement about artistic truth:

There are, in my opinion, two elements in a work: the element of reality, which is nature, and the personal element, which is man. The element of reality, nature, is fixed, always the same; it is given equally to all men; I would suggest that it may act as a common term for all works, if I were to admit that there could be any common term. The personal element, man, is, on the other hand, infinitely variable; there are as many possible works as there are different minds.[10]

Pissarro's artistic methodology is linked to his ideological outlook, which centered around a retreat from metropolitan systems of authority—such as government institutions and official art establishments—and a belief in an egalitarian, utopian society, influenced by the anarchist literature he read. Although he never painted overtly political themes, he strongly advocated art that upheld "our modern philosophy which is absolutely social, anti-authoritarian and anti-mystical."[11]

In a painting from 1872 entitled *Cart on a Road, Near Louveciennes, Winter* (pl. 9), for example, a sweeping country road slowly curves around a small hill toward the foreground, focusing the work on the figures at center and leading the viewer into the scene. Two figures in a horse-drawn carriage descend toward the viewer as a female figure climbs the brown, muddy road with her back to us. Here the approaching vehicle stands taller than the house in the background due to its placement near the top of the hill, yet it is dwarfed by the bare tree reaching past the top of the canvas into the grey winter sky. There is no hierarchy evident between the figures, only an integration of nature and humanity. The scene conveys a sense of slow but deliberate progression: people, animals, and nature each move along the course of their mundane but vital existence, perhaps acknowledging each other as they go about their daily business. Pissarro's intention is to avoid the narrative and the symbolic. Here, the path is not an emblem of movement or progress as much as it is a physical and visual indicator of going from place to place. With respect to technique, Pissarro took an avant-garde approach—using strokes of paint applied with brush and palette knife, focusing on optical blending of colors and leaving out much detail—eventually associated with the Impressionists. The technical innovations he pursued went against the established conventions of painting of the time and are thus connected with Pissarro's overall anti-establishment philosophy.

During the 1860s and 1870s, when Pissarro was formulating his approach to painting, he was also developing his ideas about the sociopolitical world around him. In reading anarchist thinkers such as Pierre-Joseph Proudhon and Prince Peter Kropotkin and discussing avant-garde ideas with his contemporaries, Pissarro developed an adamantly leftist ideology. He espoused Proudhon's belief that "art cannot subsist apart from truth and justice; that science and morality are its leading lights; that it is, indeed, ancillary to these; and that its first law is therefore to respect

morals and rationality.["12] His anti-bourgeois stance manifested itself in his desire to break down social hierarchies, class distinctions, and ethnic and religious differences, as well as the hierarchies in the established art institutions of his time. Pissarro's paintings subtly reveal his intellectual movement away from his bourgeois upbringing toward the leftist avant-garde. While early works show the influence of traditional landscapists such as Corot, whom Pissarro admired even as he diverged from his example, his work in the 1860s begins to take on social implications while avoiding didacticism or overt political themes.

This can be seen in Pissarro's *The Brook at Montbuisson, Louveciennes* (c. 1869; pl. 6), which shows the artist's almost seamless integration of peasant life and the rural environment. A peasant woman, barely discernible among the autumn leaves and earthy ground, bends over the banks of an even less visible brook, which forms a horizontal path across the lower part of the composition and further distances the woman from the small farmhouse behind the trees. The separation isolates the figure within her work, while integrating her into what Pissarro perceived as the peasants' intrinsic natural surroundings, a viewpoint he envisioned for himself as well: "I have the temperament of a peasant, I am melancholy, harsh and savage in my works.["13] While he associated himself with the peasants, he recognized that he could never entirely divorce himself from his bourgeois background, at one point calling himself "a bourgeois without a penny." What did align him with the peasantry, however, was his marginal status in society as a non-French (Danish) citizen, an anarchist, and a Jew.

While his paintings do not express his political views explicitly, Pissarro's personal life more dramatically reflected his anti-authoritarian outlook. After his rebellious abandonment of the family business, Pissarro further disrupted his family's social status by marrying not only a non-Jew, but a woman of the servant class—his mother's cook's assistant—whom his mother never fully accepted. Pissarro and Julie Vellay lived as common-law spouses from the early 1860s until their civil marriage in 1871 while in exile in London during the Franco-Prussian War. Julie bore Pissarro eight children, three of whom died young, and managed a growing household that moved frequently on her husband's meager income. From Pissarro's letters to his son Lucien, it is apparent that Julie was constantly worried about the family's

finances, and, unlike her husband, who encouraged all of his sons to become artists, she advocated learning a marketable trade. He wrote to Lucien, "I would much rather be a worker than a businessman who is actually nothing but a middleman or intermediary, and should properly conduct his business for the worker's profit." Instead of making money, Pissarro expressed the desire to have "the satisfaction of living by my ideas."[14]

Working Paths and Fields

PISSARRO SPENT MUCH OF his time between 1870 and 1878 at Montfoucault, the farm in Brittany of his friend the painter and liberal politician Ludovic Piette, where he had the opportunity to closely study a working farm firsthand (fig. 5 and pls. 12–14; see also Shiff essay, figs. 13, 15).[15] A scene of the farm in winter (fig. 5 and pl. 14) shows a man on horseback riding away from the viewer along a snowy path. For Pissarro, the path denotes the process of getting work done, both physically and ideologically. Pissarro saw himself as a worker, and indeed he worked laboriously on solving aesthetic, technical, and ideological problems in his art: "Work is a marvelous regulator of moral and physical health. All the sadness, all the bitterness, all the grief—I forget, I overlook these in the joy of working."[16] Art historian Richard Shiff has astutely remarked that, for Pissarro, the work of the artist paralleled the work of the peasants he depicted. That is, the labor-intensive practice of painting, with its individual rhythm and pace, is akin to the repetitive labor of hoeing, milking, or plowing. Pissarro aimed "to eliminate hierarchy and privilege"[17] in both painted subject matter and working method.

For Pissarro, the work of painting was closely tied with his anarchist leanings, and this was embodied in the radicalism of the Impressionist and especially his later Neo-Impressionist technique. The unfinished look of the Impressionists' canvases shocked conservative critics, one of whom, upon viewing an Impressionist exhibition in New York in 1886, declared that their work was a "deliberate campaign against legitimate art."[18] This unfinished quality is evident in Pissarro's 1875 painting *Peasant Women Shifting Straw, Montfoucault* (pl. 13), in which women work in a flurry of rough brushstrokes of paint laid down on the canvas with minimal mixing of

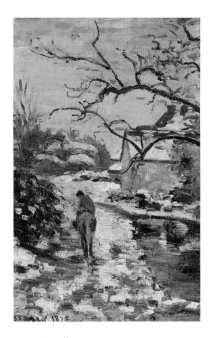

Fig. 5. Camille Pissarro
Winter at Montfoucault, Man Riding a Horse, 1875 (detail of pl. 14)
Oil on canvas, 18⅛ × 21⅝ in.
(46 × 55 cm)
Collection of Michael and Henry Jaglom

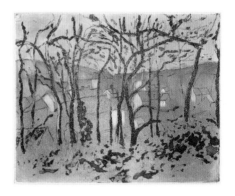

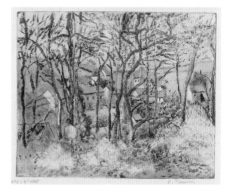

Fig. 6. Camille Pissarro
*Wooded Landscape at
L'Hermitage, Pontoise,*
1879
Softground etching and
aquatint on cream wove
paper, first state, plate:
8¼ × 10½ in. (21.6 ×
26.7 cm)
Museum of Fine Arts,
Boston, Lee M. Fried-
man Fund (1971.267)

Fig. 7. Camille Pissarro
*Wooded Landscape at
L'Hermitage, Pontoise,*
1879
Softground etching and
aquatint on beige laid
paper, fifth state, plate:
8¼ × 10½ in. (21.6 ×
26.7 cm)
Museum of Fine Arts,
Boston, Lee M. Fried-
man Fund (1971.268)

colors. Another critic scornfully proclaimed that "Impressionism in art is some-
thing parallel to socialism in politics."[19] While not true of the work of the less-
political Impressionists, Pissarro was attempting to convey "a general idea of the
movement which points to the new road our society must take."[20]

Crossroads and Convergences

PISSARRO'S COLLABORATIONS AND DISCUSSIONS with other artists and intellectuals
produced a fruitful convergence of ideas and methods. This is evident in his
relationships with Paul Cézanne and Edgar Degas and, in the late 1880s, his
association with the Neo-Impressionists. In particular, the interchange of styles
and ideas that materialized from the dynamic friendship of Pissarro and Cézanne
as they painted together from the early 1860s to the mid-1880s has been dis-
cussed extensively and persuasively by Joachim Pissarro.[21]

These artists, along with most of the Impressionists, were inspired by
Japanese prints. However, few took an active interest in making prints with the
notable exception of Degas and Pissarro, who, despite their vastly different
social and political backgrounds, collaborated on new approaches to printmak-
ing beginning in 1879.[22] Degas planned to publish a journal of prints, *Le Jour et
la Nuit,* to which artists would contribute original works. Pissarro's contribution
was to be the etching with acquatint and drypoint entitled *Wooded Landscape at
L'Hermitage, Pontoise* (pl. 18; see also figs. 6, 7), based on his painting of the same
title of 1879. Although the journal was never published, Pissarro successfully
completed his etching intended for inclusion. This work is a striking composi-
tion of a dense wooded thicket that partially obscures a view of Pontoise as it
suggests the horizon and skyline above. Here the path the man takes through
the woods is only implied, hidden by thick brush. As in Japanese prints, the
foreground, middleground, and background are flattened so that the space feels
condensed and abstracted, yet overall the work has an elegant rhythm of geo-
metric and organic lines. As Barbara Stern Shapiro points out, Pissarro's print-
making was unique in that he chose to annotate and sign each impression rather
than just the final state.[23] For Pissarro, the experimentation and changes made

the process as important as the final product. Significantly for Pissarro, printmaking itself was genuinely communal work—the artist creates the image and works with a printer and sometimes an engraver or woodcutter to create the final print. In addition to his work with Degas, Pissarro often collaborated with his son Lucien on prints and also contributed prints to anarchist publications. The convergence of ideas, working processes, and the mass distribution that printmaking allowed all coincided with Pissarro's liberal philosophy.[24]

In the mid-1880s, when Pissarro was in his fifties and well established (and finally financially successful) as an Impressionist painter, he became interested in the scientific artistic theories advocated by artists of his son's generation, specifically those of Georges Seurat and Paul Signac. The rigorous technique and interest in color theory appealed to Pissarro, who read extensively about the topic.[25] Pissarro espoused their Divisionist or Pointillist techniques and began making works in the Neo-Impressionist style, which he deemed to be "a new phase in the logical advancement of Impressionism."[26] By this time, various members of the Impressionists had been at odds for several years, some wanting to split off from the rest of the group. Pissarro—fully immersed in his new style to the point of calling the older Impressionists "romantic Impressionists" as opposed to the new "scientific Impressionists"—still desired cohesion for the group and managed to organize the eighth and final Impressionist exhibition in 1886, in which he exhibited his work along with that of Seurat and Signac and Lucien Pissarro in a separate Neo-Impressionist gallery.[27]

One of Pissarro's attractions to Neo-Impressionism was its association with anarchism.[28] The mid- to late 1880s was a time of great social unrest in Paris. Trade unions were legalized as the left gradually rose. At this time, Pissarro was reading leftist newspapers such as *Le Prolétaire* and *Le Révolté* and works by anarchist writers. He also met leftist writers, including Félix Fénéon, who coined the term Neo-Impressionism. In an 1887 article on this new style, Fénéon wrote that a handful of artists, including Pissarro, Seurat, and Signac, "achieve the sensation of life itself: this is because objective reality is for them only a pretext for the creation of a higher, sublimated reality, which becomes infused with their personalities."[29] Pissarro himself echoed these ideas in a letter to Lucien: "I firmly believe that something of our

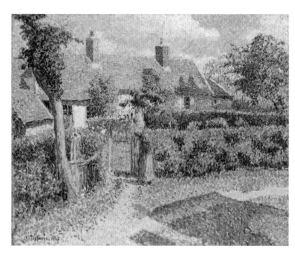

Fig. 8. Camille Pissarro
Peasants' Houses, Éragny,
1887
Oil on canvas, 23¼ × 28¼ in.
(59 × 71.7 cm)
Art Gallery of New South
Wales, Sydney, Australia,
Purchased 1935 (6326)

ideas, born as they are of the anarchist philosophy, passes into our works which are thus antipathetic to the current trend."[30] In a Neo-Impressionist work from 1887 (fig. 8), Pissarro utilizes the unmixed dots of paint and vibrant color of the new theory. Here a peasant woman carrying a pack on her back bends as she walks along a garden path, unified with her surroundings, autonomous from any bureaucracy in far-away Paris.

Pissarro's constant experimentation with his technique produced questioning and even disdain from his critics: "Mr. Pissarro is the intransigent of the intransigents. Whatever his qualities may be, I refuse to believe the sincerity of his impression translated through a method of stippling which removes the fresh and free appearance that a work should always preserve."[31] Although his Neo-Impressionist work did not sell well, he continued to progress along his own individualistic path, stating, "But I know where I am going," even as that path continually meandered.[32]

Urban Passages

AN ETCHING DEPICTING THE Place de la République in Rouen of 1883 (pl. 33) provides a glimpse of the street below the artist's window shrouded in misty weather. While beginning work on a painting of the same scene, Pissarro wrote to Lucien: "I must leave you for my motif. I have a room on the street. I shall start on a view of the street in fog for it has been foggy every morning until eleven o'clock [or] noon. It should be interesting, the square in the fog, the tramways, the goings and comings."[33] Like the subject of many of Pissarro's urban scenes, the bustling square is a crossroads of people, horse-drawn carts, trams, and, in this case, the dock and river with boats in the background. From his vantage point above the square, Pissarro observes the "goings and comings"—the passage of people, both workers and bourgeois, and of weather and time. Pissarro used the word "passage" to explain his latest technical experimentations, which moved him away from what he increasingly found to be the harsh contrasts and lack of spontaneity in the Neo-Impressionist technique.[34] Passage can also suggest the modern transitions—in geographic location,

artistic methodology, and political ideology—embodied by Pissarro's pathways.[35]

At the end of the 1880s, Pissarro felt that the labor-intensive process of the Pointillist technique took him away from the "sensations" that had previously animated his work. "I think continually of some way of painting without the dot. I hope to achieve this but I have not been able to solve the problem of dividing the pure tone without harshness. . . . How can one combine the purity and simplicity of the dot with the fullness, suppleness, liberty, spontaneity and freshness of sensation postulated by our impressionist art?"[36] In keeping with his relentless reworking of method, Pissarro finally abandoned the Neo-Impressionist technique and returned to his Impressionist style. His subject matter, however, took a radical turn.

In his later years, Pissarro spent a great deal of time in Paris, as well as in London, Rouen, Dieppe, and Le Havre. Although he had occasionally touched on urban subjects earlier in his career, he now devoted the majority of his work to city scenes. Pissarro's cityscapes—often painted from the elevated perspective provided by his hotel room or rented apartment—portray the convergence of busy streets brimming with pedestrians, carts, and horses in various weather conditions. Many complex reasons, both political and personal, may have accounted for Pissarro's movement toward the city as subject, including a recurring eye infection that kept him indoors and the fact that his cityscapes sold well.[37] Whatever the reasons for his sojourns, Pissarro became the foremost Impressionist painter of cityscapes and made more than three hundred paintings of cities in the last decade of his life. While he still lived in and painted rural scenes in Éragny (see pl. 47), his late work is heavily concentrated on urban settings. His city scenes, many completed in series, often retain his characteristic motif of the path but in its urban incarnations as streets, bridges, quays, and garden walkways. In addition, Pissarro's late works retain his lifelong interest in social radicalism, even as he achieved financial success.

French politics, particularly the controversy surrounding the Dreyfus Affair, are integral to Pissarro's late cityscapes, even if they are not readily visible. Richard Brettell and Joachim Pissarro convincingly argue that this is especially true in his series of ten paintings depicting the Avenue de l'Opéra (1897–98; fig. 9 and pl. 44).[38] Pissarro began painting from a room in the Grand Hotel du Louvre overlooking the Avenue de l'Opéra and the Place du Palais Royal in 1897: "It is very beautiful to

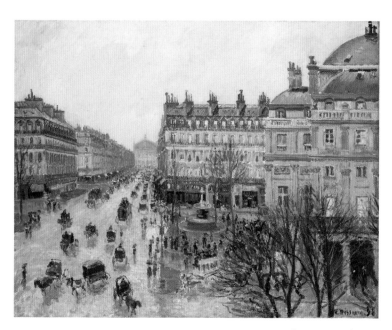

Fig. 9. Camille Pissarro
*Place du Théâtre Français,
Paris: Rain*, 1898
Oil on canvas, 29 × 36 in.
(73.6 × 91.4 cm)
Minneapolis Institute of
Arts, The William Hood
Dunwoody Fund (18.19)

paint! Perhaps it is not aesthetic, but I am delighted to be able to paint these Paris streets that people have come to call ugly, but which are so silvery, so luminous and vital. . . . This is completely modern!"[39] Pissarro was, however, acutely aware of the growing social unrest and anti-Semitism that had gripped Paris. Before traveling to Paris, he wrote to Lucien, "I am sending you a batch of newspapers that will bring you up to date on the Dreyfus case, which is so agitating public opinion. You will realize that the man may well be innocent, at any rate, there are honorable people in high positions who assert that he is innocent."[40] Although the French Jewish officer Alfred Dreyfus had been convicted of espionage several years earlier, it was not until the late 1890s that the public became aware that the evidence used to convict him was false and based on anti-Semitic assumptions. About a month after he arrived in Paris, Pissarro wrote, "The Dreyfus case is causing many horrible things to be said here. . . . Today Zola accuses the General Staff . . . but the bulk of the public is against Dreyfus."[41] Public opinion was fiercely divided, as were the opinions of the Impressionist artists. While Cézanne, Renoir, and Degas supported the French government, Pissarro, Monet, and Mary Cassatt aligned themselves with the Dreyfusards. As an anarchist, Pissarro did not immediately take a stance, but his humanism and anti-authoritarian beliefs prevailed, and his support of Dreyfus became ardent. It also alienated him from certain former colleagues and allies and caused him concern that he, too, could be the victim of anti-Semitic hostility. In a letter to Lucien, Pissarro relates the story of how he passed through a gang of "young scamps seconded by ruffians" who shouted "Death to the Jews!" without recognizing Pissarro himself as a Jew. As was characteristic of Pissarro's work, his paintings from this volatile time in Paris never overtly depict anything political, such as demonstrators in the streets, and he reveals in his writings that he attempted to separate the events of his day from his painting: "Despite the grave turn of affairs in Paris, despite all these anxieties, I must work

at my window as if nothing has happened."[42] Yet the *Avenue de l'Opéra* series, painted while Pissarro could not distance himself from the outside world, suggests a passageway or connection between the reality of the times and his artistic pursuits.

During the time he was painting his city series, Pissarro completed a series of satirical drawings entitled *Turpitudes Sociales* (fig. 10). The drawings, intended to give political instruction to his grown nieces in London, illustrate Pissarro's anti-society and pro-worker beliefs in a style influenced by caricaturists such as Daumier. Shockingly, Pissarro utilized Jewish stereotypes for his figures representing the vices of society, reflecting the anti-Semitic sentiment of his time that linked Jewish bankers with capitalist corruption. Pissarro wrote, "Unfortunately the masses haven't the least understanding of what is going on; they assume a social struggle is being waged against Capital without asking themselves who will be defeated—they dislike the Jewish bankers, and rightly, but they have a weakness for the Catholic bankers, which is idiotic."[43] However, it is a Jewish stereotype that Pissarro chooses to illustrate his dislike of bankers. As others have pointed out, this practice was in keeping with the convention of his time and also reflects Pissarro's position as a secular Jew and an anarchist.[44] The scholar Richard Brettell links Pissarro's contemporaneous *Turpitudes Sociales* with his late cityscapes: "With [*Turpitudes Sociales*] in mind, the melee of social classes, sexes and ages in his urban paintings forms a sort of visual/political manifesto in which the city can be interpreted as a vast setting for social and economic interaction."[45] This interaction—or path—between artistic and political ideas is what remains constant in Pissarro's work.

Painted in the year of the artist's death at age seventy-three, *The Pont-Royal, Bright Cloudy Weather (Fourth Series)* (1903; pl. 49), was one of a series of seven paintings of this scene executed from his rented room on the Quai Voltaire in Paris, where he had a view of the Pont-Royal opposite the Louvre's Denon wing and the pavilion de Flore on the Right Bank. In it, people and vehicles along the quay and the bridge move along their individual routes. While Pissarro's path motifs can be seen both as literal and ideological approaches and retreats, Pissarro himself remained committed to his course away from convention and toward an evolving and individualistic ideology. In the last year of his life, Pissarro summed up his lifelong artistic route: "One only finds one's own direction after having worked for a great many years."[46]

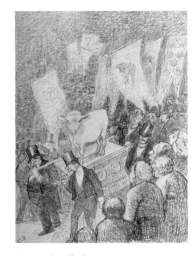

Fig. 10. Camille Pissarro
*The New Idolators
(Illustration for Turpitudes Sociales)*, 1890
Paper and ink drawing,
23 × 18 in. (58.4 × 45.7 cm)
Denver Art Museum Collection, The Edward and Tullah Hanley Memorial Gift to the People of Denver and the area (1974.395)

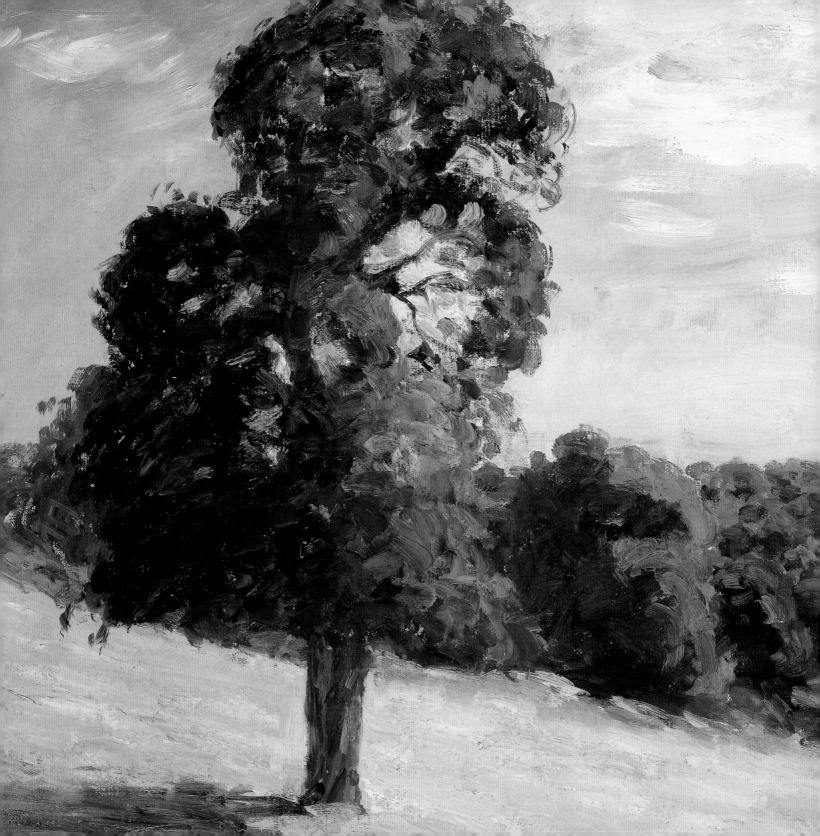

Richard Shiff

PISSARRO: DIRTY PAINTER

Anti-Millet

In April 1904, five months after the death of Camille Pissarro, the Durand-Ruel Gallery honored his memory with a retrospective exhibition.[1] The title page of the accompanying catalogue reproduced an image of a peasant woman digging in the earth, one of the artist's drawings converted to wood engraving by his son Lucien (fig. 1). The peasant stood as paradigmatic of Pissarro's concerns: the life of workers, the dignity and moral reward of work, the restorative benefit of being grounded in one's work—whether by contact with the soil of the fields or by engagement with paint and canvas in the studio. This was not a romantic's view of the wonders of nature or the mysteries of creative genius; it was a materialist's understanding of the productive labor that sustains human life, mentally as well as physically.

The catalogue opened with an essay by the novelist Octave Mirbeau, who had known Pissarro personally since around 1885 and was in sympathy with his combination of Impressionist aesthetics and anarchist politics. Mirbeau cited Pissarro's belief that work becomes life's "joy," relieving sorrow, pain, and depression.[2] As a foundation for his essay, he turned to his own earlier writings, closely related statements of 1890 and 1892, from which he redeployed his metaphors. The psychological reward of labor—the emotional well-being that individuals derived while working to create harmony in artistic form or cultivating the land—produced a social bond without imposing social organization. Mirbeau drew extended parallels between Pissarro's work and the way he represented others at work: harmony redoubled (see fig. 2).

The critic refined his basic message for the memorial exhibition, providing a summation of Pissarro's career and character: "It's the life of the land that Camille Pissarro expresses, without resorting to sentimentality or extraordinary effects.

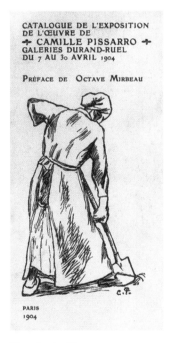

CATALOGUE DE L'EXPOSITION DE L'ŒUVRE DE ✦ CAMILLE PISSARRO ✦ GALERIES DURAND-RUEL DU 7 AU 30 AVRIL 1904

PRÉFACE DE OCTAVE MIRBEAU

PARIS
1904

Fig. 1. Lucien Pissarro (French, 1864–1944) *Cover of Durand-Ruel Gallery Retrospective Exhibition Catalogue for Camille Pissarro*, 1904 Wood engraving

OPPOSITE PAGE: Detail of fig. 15

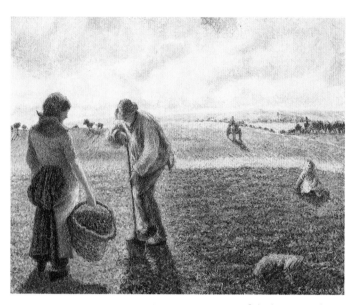

Fig. 2. Camille Pissarro
(French, 1830–1903)
*Peasants in the Fields,
Éragny*, 1890
Oil on canvas, 25⅜ × 31⅝ in.
(64.4 × 80.3 cm)
Albright-Knox Art Gallery,
Buffalo, New York, Gift of
A. Conger Goodyear, 1940
(40:20)

More than any other, he will have been truly the painter of the soil and of our soil. . . . When he paints figures in scenes of agrarian life, man always takes his proper place within a vast earthly harmony."[3] By this account, Pissarro's art presented an ideal for contemporary France ("our soil") as well as a reflection on work as the universal human condition. In 1904, but even more so in 1890, Mirbeau contrasted Pissarro to his celebrated predecessor in representing field workers, Jean-François Millet. This was not surprising, for many other commentators had been noting the two painters' analogous involvement with agrarian themes. Mirbeau may have emphasized that Pissarro's art was "without sentimentality" (*sans anecdotes sentimentales*) because he attached this characteristic to Millet. Pissarro became the anti-Millet, a position he willingly occupied.[4] Millet's failing was his tendency to project his peasant subjects against, rather than within, the land, as if their rural environment were no more than a stage set behind them. This meant that the expressive burden of the picture would be carried almost exclusively by the posturing of the represented human body, causing Millet's art to resemble traditional forms of academic painting, with overtones of mythology and religion. To the contrary (so Mirbeau argued), Pissarro's peasants bonded with the land; they were "fused with the earth," growing from it like plants in pantheistic harmony, fulfilling an anarchist's dream.[5] In Pissarro's painting, figure and environment were one.

Pissarro answered Millet's staged drama of the peasant with a drama of the earth: "To describe for us the drama of the earth and to affect us emotionally, Pissarro has no need to employ violent gestures, complicated arabesques, or an ominous gathering of storm clouds. A hillside silhouetted against the sky with a passing cloud—this is enough."[6] The painter stuck close to local conditions not only in what he represented but also in how he represented it; despite his inventiveness, his technique remained straightforward and without rhetorical embellishment.[7] A strong emotional force nevertheless developed. Out of what? Mirbeau wrote of "the drama of the earth," which Pissarro would somehow convey without resorting to

extraordinary graphic means: no "violent" (that is, excessive) gestures, no "complicated arabesques." He showed formal restraint at the same time that he projected intense emotion. Was there a secure connection between the two sides of the Pissarro equation—between his emotional feeling for the soil and his use of a humble, earthy technique with no pretense to transcend the materiality of the means? Pissarro freely exposed his means, referring to his "crude, rough-cut execution" and "wildness" (in the sense of naturalness, being close to a natural state). Exposure had its problems: "I would like to have a smoother application, nevertheless retaining the same qualities of wildness [*qualités sauvages*], while eliminating the distracting harshness that allows my canvases to be viewed only when lit from the front."[8] Raking light hit Pissarro's textured paint like a rising sun hits a furrowed field, generating "rough-cut" shadows.

Making his case for Pissarro contra Millet, Mirbeau suggested that the older painter retained a certain conventional polish, if not in the handling of texture then in the rhetoric of composition. Millet "belittled" his figures even as he rendered them monumental in their pictorial isolation. His scenes remained "anecdotal," Mirbeau argued, with the effect of reducing a worker's posture to an expressive cliché.[9] This criticism was hardly objective. Millet was actually adept at integrating figures with the rhythmic and textural qualities of the land he conceived as their (pictorial) environment. His representation of the earth in *Man with a Hoe*, 1860–62 (fig. 3), reveals an involvement with the physicality of paint and its brushwork that Pissarro may well have admired. Millet worked with a suitable intensity. From Pissarro's perspective, however, he erred when he silhouetted a figure against a relatively uninflected sky. This became a pictorial conceit, a dramatization for emotional effect.[10] Perhaps Pissarro recognized that plays on emotion must entail either a dimin-

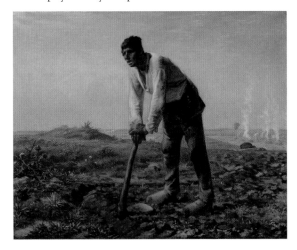

Fig. 3. Jean-François Millet
(French, 1814–1875)
Man with a Hoe, 1860–62
Oil on canvas, 31¼ × 39 in.
(80 × 99 cm)
The J. Paul Getty Museum,
Los Angeles (85.PA.114)

ishment of actual emotion or a shift in the character of the emotion. His paintings avoid Millet's pathos.

Much of the divergence between Pissarro's manner and Millet's is nevertheless only a matter of degree. Insisting on the seriousness of the difference, Pissarro and the like-minded Mirbeau must have been particularly sensitive to the way that the handling of a paint surface and the staging of its scene can affect similar representational subjects. Pissarro sometimes created figures that tend toward monumentality, approaching the disposition of Millet's (see pls. 22, 48). Yet the insistent evenhandedness of Pissarro's paint surface reestablishes a division between the two artists. It becomes all the more pronounced in works where Pissarro placed his figures incidentally within the rural scene (see pl. 42). In certain images the number of paint strokes articulating a human form is hardly different from the number appearing in adjacent vegetation or clods of earth, with the figure and its surrounding ground sharing the same low degree of resolution. In 1905, the critic Charles Morice put the matter bluntly: "I've noticed that in Pissarro's paintings, the human figures, quite precisely, have the same import as the vegetables beside them."[11] Two examples, one relatively early, one relatively late: in *Sunlight on the Road, Pontoise*, 1874 (fig. 4), Pissarro rendered his figures as summarily as the dirt of the carriageway and the adjacent grasses; in *Port of Rouen: Unloading Wood*, 1898 (fig. 5), he set figures, paving stones, ship's rigging, water, and smoke under the same coarse lens.

Fig. 4. Camille Pissarro
Sunlight on the Road, Pontoise, 1874
Oil on canvas, 20⅝ × 32⅛ in.
(52.4 × 81.6 cm)
Museum of Fine Arts, Boston, Juliana Cheney Edwards Collection (25.114)

Fig. 5. Camille Pissarro
Port of Rouen: Unloading Wood, 1898
Oil on canvas, 28¾ × 36¼ in.
(73 × 92.1 cm)
The Sterling and Francine Clark Art Institute, Williamstown, Massachusetts (1989.3)

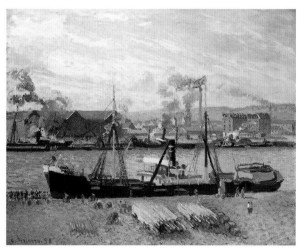

For better or worse, critics made an observation of evenhandedness repeatedly, indirectly acknowledging that Pissarro, along with his Impressionist colleagues, aimed at an integrated pictorial effect.[12] While seeking a uniform sense of light and atmosphere, the Impressionists often sacrificed details. Evenness in paint handling was a reliable device for creating their desired airiness, but neither evenness nor airiness need have been established in their specific way. Their means to their end was decidedly arbitrary: while decreasing the differentiation of representational elements, they increased the painting's materiality—letting paint look like paint. Pissarro often took this material element of Impressionist practice to extremes. In a review of 1887, Mirbeau may have hit on just the right metaphor, fusing the contradictory qualities he sensed in his friend's art, its simultaneous evocation of vaporous diffuseness and clotted denseness: "He paints the smell of the earth."[13]

Pure Pissarro

A PAINTING NEITHER EARLY nor late within Pissarro's career, *Ploughing at Éragny*, c. 1886 (pl. 27), is a viscous mass of marks radiating a brilliant light. Its human element, the figure at the plow—those few marks among the many—is no more than incidental, even though an interpreter, sympathetically attuned to any human image, might grant it a commanding presence. The painting belongs to a group of small works on panel that Pissarro made as he experimented with Georges Seurat's Pointillist technique during the late 1880s. A good part of the attraction of Seurat's method was its refinement: it offered a way to remain true to immediate visual sensation while progressively moderating the coarseness of the textured surface and its visual effect. Pissarro stated in 1886 that with enough "time and patience" given over to this method, he could expect to reach an "astonishing subtleness" (*douceur*).[14] The opposite direction—unadulterated chromatic brilliance—was also possible. Working with Seurat's "point," Pissarro rendered the tile roof of a farm building so shockingly red that he felt he had scared off potential collectors.[15]

Despite his commitment, Pissarro's paintings in the Pointillist mode are rarely as rigorous and controlled as Seurat's (see fig. 6). With a few exceptions, his small panel studies seem impetuous—or perhaps merely impatient—as if the

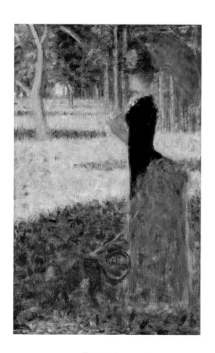

Fig. 6. Georges Seurat
(French, 1859–1891)
*Woman with a Monkey
(Study for "A Sunday After-
noon on the Island of La
Grande Jatte")*, 1884
Oil on wood panel, 9¾ ×
6¼ in. (24.7 × 15.9 cm)
Smith College Museum of
Art, Northampton, Massa-
chusetts (SC 1934:2-1)

restrictions of the Neo-Impressionist order put him at odds with his instincts. He eventually complained that the "systematic division" of color made it impossible for him to respond to his most transient sensations, and that the system brought about a "deadly leveling" (deadly to feeling).[16] *Ploughing at Éragny* has little "leveling" in any respect. Its color approaches garishness, and its structure tests the tolerances of tra-ditional relations of figure and ground. Where the plowman's head projects above the horizon and into the sky, the dark reserve of the panel becomes a positive fig-ure; but just beside it and to about the same degree of resolution, fragments of the reserve function as a negative ground articulating the pale blues and the whites of the sky and clouds. In one area of the continuous pictorial field, the visible frag-ments of panel function as representation; they assume a specific form, but only with the crudest approximation. Just beside this, fragments of the same ground facilitate representation, but without assuming any form of their own. In Pissarro's time, there was a term for a painter's mark of this type, one looking much the same whether defining a representational form or merely filling a space: this term was *pure*. In 1899, Paul Signac (presenting a history and theory of Pointillism) argued that Paul Cézanne had liberated his technique from the two demands of conventional practice—representational accuracy and aesthetic embellishment. In this sense, Cézanne's technique was "pure": "strokes rectilinear and pure, concerned with nei-ther mimeticism nor artfulness."[17]

Pissarro's reserve of ground (at least in his small panel paintings) is at once form and formlessness. It operates as an element of a representational sign that crudely signifies selected visual features of an identifiable thing. But then it shifts abruptly to a state of pure form or pure formal function, that is, a state of repre-sentational formlessness. At this moment of conversion, the ground color is all potential, available to signify anything. Another way to say this: the color reverts to its condition as medium. In this indeterminate, non-referential state, the painter's ground resists any well-formed visual logic; it isolates visual experience from the rational systems that would explain it, dividing seeing from thinking. With no con-cept to preoccupy us, we see the color in its immediacy.

This tension is thoroughly common in visual art: we view the image as a reliable projection while also being fully conscious of its fictive, handmade nature.

The material base or ground of a medium supports the image but also intrudes into the scene, as if in a state of purity, representing nothing but itself. In this respect, the ground interferes like dirt on a lens—dirt that is pure—a self-contained spot on the transparency of the image. Whether a viewer is induced to reflect on the presence of interference, either becoming fixed on it or consciously choosing to ignore it, depends on the context of reception, which must have a historical dimension. Morice's comment of 1905 might have been written this way: "I've noticed that in Pissarro's paintings, the human figures have the same import as the pure paint marks beside them." Morice brought this type of observation to bear specifically on Cézanne, who (the critic argued) reduced the moral value of his subjects to a question of mere color values.[18] To follow the various lines of critical commentary around the turn of the twentieth century is to realize that Pissarro and Cézanne lived through a time when the painter's means of figuration was rapidly coming unhinged from its figure. Observers were choosing not to ignore the interference factor; they saw the dirt.

The Artist's Palette with a Landscape, c. 1878 (fig. 7), a novelty Pissarro created for a collector, acquires in retrospect an emblematic significance the painter is unlikely to have imagined.[19] Here the support is a "palette" in a double sense: on the one hand, a wood panel suitable for carrying and mixing paints; on the other hand, an array of six deposits of paint of different colors, destined to become the component hues of the rendered scene. As Pissarro painted peasant laborers at the center of his palette, he left the surface conspicuously free of paint around the thumb-hole and out toward the edges. His conceit was to make a painting while preserving the functional potential of the painter's equipment: the palette retains its use in laying out colors, in being available to an artist's grasp, and in providing a rectilinear working surface. Pissarro's scene of work appears on his surface of work.

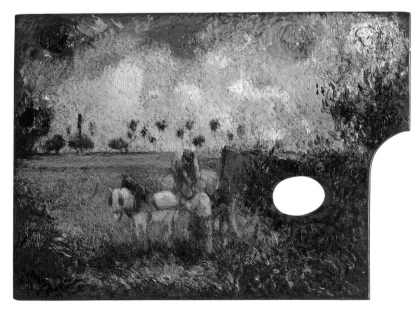

Fig. 7. Camille Pissarro *The Artist's Palette with a Landscape*, c. 1878 Oil on panel, 9½ × 13⅝ in. (24.1 × 34.6 cm) The Sterling and Francine Clark Art Institute, Williamstown, Massachusetts (1955.827)

His image of agrarian labor looks tentative, on the cusp of a figure/ground dilemma, as if reversible in time and materiality: it might be scraped down, restored to six lumps of paint, then returned to the earth as pure substance.

Anti-Monet

JUST AS HE BECAME sensitive to comparisons with Millet who preceded him, Pissarro was at times intent on articulating his difference from a colleague ten years his junior, Claude Monet. Regarding Pissarro and Monet as cofounders of the Impressionist movement, Mirbeau supported both (personally, he was closer to Monet).[20] In Pissarro's estimation, the divergence of the two painters become most pronounced during the period of his involvement with Seurat's methods. He argued that Monet avoided the question of a proper degree of control by yielding to his "romantic fantasy" of color, letting some of his paintings became incomprehensibly bright while others grew muddy from odd combinations of pigments.[21]

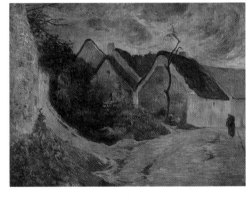

With respect to his judgment of Monet's irregularities and excesses, Pissarro had an ally in Paul Gauguin. On several occasions during the early 1880s, Gauguin accompanied him in the countryside as the two painted rural hamlets and cultivated fields; it was Gauguin's learning process. He quickly acquired his master's Impressionist manner, though his pictures looked flatter and less nuanced because his touch was somewhat stiffer than Pissarro's (compare fig. 8 to fig. 9). Gauguin laid out sequences of repetitive paint strokes to form linear patterns within the atmosphere suggested by his color—a method that undermined the illusion of space even as his painting was creating it. If this way of working puzzled many contemporaries, Gauguin felt it had the compensating merit of avoiding any trickery; he achieved his effects using paints and brushes straightforwardly, following Pissarro's direction perhaps farther than his mentor may have wished. Pushed farther still, the technique developed into

Gauguin's "primitivism"—not unrelated to Pissarro's own "natural wildness" in matters of the brush, his *qualités sauvages*.

Gauguin sent Pissarro a note in July 1884 after seeing new works by Monet and Cézanne on view in Paris. He complained that Monet's showy technique, despite a "stunning execution," set a "very dangerous" precedent. To the contrary, Cézanne's art had purity: "the wonders of an art essentially pure," one that abandoned every traditional form of embellishment.[22] Gauguin was probably objecting to the kind of gratuitous flourish of the brush typical of Monet—it often appeared in his rendering of cloud formations—as if present only to demonstrate the dexterity of the painter, an instance of what Signac and others called "artfulness" (see fig. 10). Perhaps Monet took pleasure and even solace in this type of handling, just as Pissarro did in more humble paint work; if so, the difference between the two pleasures would be debatable as a moral issue. One of Gauguin's letters several years later expressed his disdain for self-indulgent "messing around with the brush."[23] At a moment of Pointillist enthusiasm in 1886, Pissarro could only agree: "As for execution, we don't bother with it at all."[24] He meant: no fancy handling, no flourish, no affectation—just the painter's ground and honest work. His creative activity might be dirty but would also be pure, and so would the painting that resulted.

If Mirbeau converted Pissarro into the anti-Millet, Gauguin by 1884 was converting Cézanne into the anti-Monet. The turn in each instance was toward directness, eliminating every sign of staging and embellishment, lest those devices divide sensation from emotion. Gauguin's involvement with Cézanne's art began in earnest in 1881 when he, Cézanne, and Pissarro painted together at Auvers.[25] As an extension of his interest in Pissarro, Gauguin took note of the bluntness of Cézanne's brushwork, which only increased the intensity of the color and the emotional force that flowed from it. This was true in paintings where the strokes moved this way and that in various areas of the composition as the painter seemed to feel his way through the complexities of a motif, ever attentive to shifts in his own sensation (see fig. 11). It was all the more true in paintings having a particularly dense

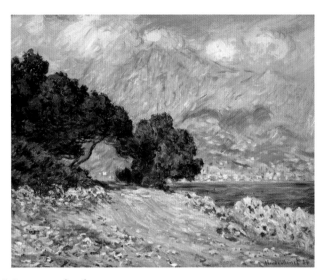

Fig. 10. Claude Monet (French, 1840–1926) *Cap Martin, Near Menton*, 1884 Oil on canvas, 26⅜ × 32⅛ in. (67.3 × 81.6 cm) Museum of Fine Arts, Boston, Juliana Cheney Edwards Collection (25.128)

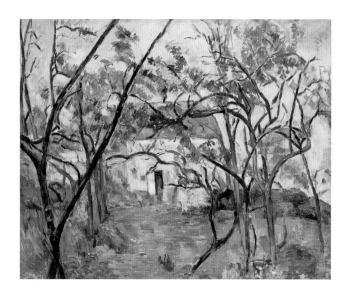
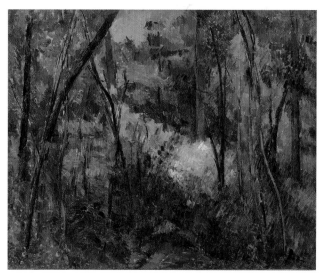

Fig. 11. Paul Cézanne
(French, 1839–1906)
House in the Country,
1879–82
Oil on canvas, 23 × 28 in.
(58.4 × 71.1 cm)
Wadsworth Atheneum
Museum of Art, Hartford,
Connecticut, Anonymous
gift (2000.11)

Fig. 12. Paul Cézanne
Interior of a Forest, c. 1885
Oil on canvas, 18¼ × 22¼ in.
(46.4 × 56.1 cm)
Art Gallery of Ontario,
Toronto, Canada, Given in
loving memory of Saidye
Rosner Bronfman by her
family, 1996

array of repetitive strokes, as if the sensation Cézanne faced were unrelenting and he could do nothing other than continue to respond until the extended moment passed (fig. 12).

Both Pissarro and Cézanne allowed the evidence of their brushwork to remain aggressively obvious; like other Impressionists, they avoided bringing their paintings to a traditional degree of finish. The method efficiently connoted the primacy of immediate experience, even if it did not actually convey the experience of the scene with this same sense of immediacy. Perceiving the scene as represented by the painting required an interpretive delay. What truly left an immediate impression was the factor of "purity": the material presence of the colored surface, grasped at an instant. The artist's array of colored paint was as evident to vision as it would be to touch if the viewer were to handle it as the artist had. Ironically, the more interference introduced by the purity factor—this materiality, this dirt on the windowlike surface of the image—the more immediate and stimulating the painting might become. This twist in reception required a viewer willing to accept a reversal of the traditional priorities, a turn from image back to ground. (Parallel to this was the turn from intellectual conception back to sensation and emotion: complaining of Millet's sentimentality was tantamount to claiming that he conceptualized and sanitized any direct experience of feeling.)

Gauguin objected to the arrogance of the calligraphic flourishes in Monet's paintings. They distracted from the image as well as from a work's fundamental grounding; they were excessive by the standards of either orientation. What would Gauguin have thought of two relatively early works by Pissarro, *Piette's House at Montfoucault, Snow Effect*, 1874 (fig. 13) and *Bouquet of Pink Peonies*, 1873 (fig. 14)? Both canvases are large in relation to most of the artist's comparable easel paintings and he signed both in full, so they are unlikely to have been mere exercises. *Piette's House* is particularly "rough-cut," and Pissarro mixed its various grays ad hoc from chromatic primaries.[26] Exhibiting more of the looseness of an ink drawing than the structured layering of an oil painting, the linear branching of trees in this painting flows freely enough to counteract the idea that mimetic accuracy may have been a controlling factor. Might such an image imply willfulness, like that imputed to Monet? Pissarro's still life raises a similar question (at least in Gauguin's moralized terms, or even Mirbeau's). The painter seems to have completed his flower composition with several flourishes of the brush at the lower right, across the table that pictorially supports the vase. The strokes resemble a draftsman's cliché, squiggles used to mark the play of light on a shiny surface. We imagine the brush gliding across the resistant canvas as if the painter were finishing off (even signing off on) his own act of polishing, a gesture somewhat at odds with the roughness or dirtiness of the picture as a whole.

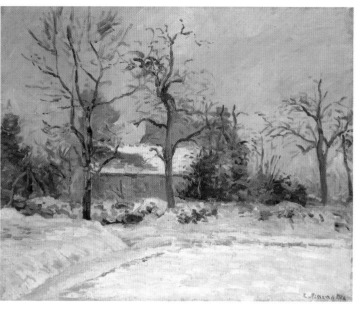

Fig. 13. Camille Pissarro
Piette's House at Montfoucault, Snow Effect, 1874
Oil on canvas, 23⅝ × 28⅞ in.
(60 × 73.5 cm)
Fitzwilliam Museum,
University of Cambridge,
United Kingdom
(PD. 10-1966)

Fig. 14. Camille Pissarro
Bouquet of Pink Peonies,
1873
Oil on canvas, 28¾ × 23⅝ in.
(73 × 60 cm)
Ashmolean Museum,
Oxford, United Kingdom
(A 820)

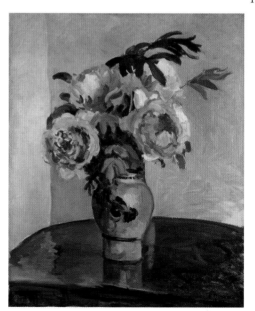

Yet, as squiggles go, Pissarro's are relatively crude. At the end of the nineteenth century, critics perceived that fine discriminations should be made between examples of painted marks of this general kind: mindless gestures or practiced ones? signifying what? Critics derived attitudes, emotions, and values from reading the marks, especially when the represented subject matter hardly varied from one artist to another. It was obvious that Pissarro, Monet, and Cézanne, however related by Impressionist concerns, painted similar vases of flowers to three very different effects.

Conceivably, Pissarro could have been seen as he saw Millet and Monet—caught up in his own technical devices and because of this, distanced from the experience and feeling he sought to represent. When he doubted the wisdom of his having adopted Pointillism, he revealed his insecurity over this deeply vexed problem. Many questioned the validity of Pissarro's art, although it is often less than evident why. The art historian Paul Mantz criticized him for clumsiness that looked naïve yet was not actually so—an affectation. Viewing a number of works in 1881 (more or less comparable to *Orchard at Saint-Ouen-l'Aumône in Winter*, 1877 [pl. 15]), Mantz concluded: "After having invented his system, Pissarro has become the victim of it. There is no air, no light, no respiration possible in his impenetrable landscapes. A monotonous execution; no respect for specific colors; everywhere the same greens, confusingly sown with spots of violet. . . . Pissarro is essentially a mannerist."[27] For Mantz, this was paradoxical: the use of naïve, uninflected paint handling on the part of a self-conscious "mannerist," that is, someone thoroughly artificial. The issue of Pissarro's genuineness remained contested. In response to every Mantz who saw "no air, no light, no respiration possible," there was a Mirbeau who would describe Pissarro's rendering of hills and fields precisely the other way round: "This pinkish earth within the greenery, this earth, too, is living; it breathes."[28]

A Historical Turn

At the heart of these distinctions and differences of response was a historical turn hard to miss for the generations who experienced Impressionism as a preexisting cultural form. Apparently, the balance between conjured image and material ground was shifting. The painting techniques of Pissarro and Cézanne—and Monet too—

were at once purer and dirtier than those of their predecessors. Art historians of the early twentieth century addressed the problem in various ways. A fundamental statement appears where one would expect it, in a book with the ambitious title *Principles of Art History*, published in 1915 by Heinrich Wölfflin.[29] He remains noted for having distinguished the modes of perception characteristic of the Renaissance and Baroque eras in the West through a comparative study of the painting, sculpture, and architecture typical of the two periods. He identified the Renaissance with linearity and its clear differentiation of diverse objects within a contained space. By contrast, he identified the Baroque with a vision he called "painterly" (*malerisch*), where "the whole takes on the semblance of a movement ceaselessly emanating, never ending . . . as if everything were of the same stuff." Wölfflin understood that when the principle is emanation and wholeness ("everything . . . the same"), it becomes impossible "to establish any ultimate expression" of the tendency.[30] Impressionism constituted an extreme of the "painterly" but not necessarily its limit.

Pissarro's *Ploughing at Éragny* (pl. 27) is painterly in many Wölfflinian senses, not the least because "everything [is] of the same stuff." Pissarro's "stuff" is more concrete than the continuous pictorial space characteristic of the Baroque and more substantial than the continuous movement and flux Wölfflin attributed to Impressionism and the Cubism he regarded as its derivative.[31] Pissarro's pervasive "stuff" is paint. Just as he worked to represent work, he used dabs of paint to represent earthen clods. In small studies such as *Ploughing at Éragny* as well as in more elaborate depictions, fields of pure, dirty painting—painting undisguised as such (which is why Mantz could see it as both naïve and mannered)—stand in for fields of dirt. The challenge to the viewer is not the closeness of this connection of paint to dirt but the representational impossibility of it, for paint that becomes so earthlike, paint that remains thick and viscous, merely looks like paint. Here an interpretive paradox emerges: when the material relationship between the pictorial sign and the pictorial representation becomes ever so close, the viewer no longer has an interpretive leap to venture. Representation collapses upon itself. Concerned more with representation than with materiality, Wölfflin recognized the problem from its other end, taking his example from Monet: "The picture of a busy street, say, as Monet painted it, in which nothing whatsoever coincides with the form we think we know

Fig. 15. Camille Pissarro
The Big Pear Tree at Montfoucault, 1876
Oil on canvas 21¼ × 25⅝ in.
(54 × 65 cm)
Kunsthaus Zürich, Collection of Johanna and Walter L. Wolf (1984/12)

in life [presents us with a] bewildering alienation of the sign from the thing."[32] No doubt, he was thinking of Monet's notorious boulevard scenes of the 1870s, in which the painter reduced human figures to dabs of black or blue. He might just as well have invoked Pissarro's urban scenes of the 1890s (see pl. 44).

Signs become alienated from the things they represent when the material basis of the sign appears problematically evident, interfering with an interpretive passage to a corroborating meaning. Painting becomes both "pure" and "dirty" by holding attention focused on itself. Viewers of Monet's and Pissarro's Impressionism often fixed on the painted surface. They understood in principle that a dab of paint could represent the earth or a man walking, but the material challenge of the painter's technique came to dominate whatever interest they took in the representational subject. Breaking ranks with prevailing standards, the technique itself

required interpretation: What human interests and values did the bond of purity and dirtiness in painting imply? Some critics were prepared to shift the attribution of meaning from the subject or thematics to the material features of the painting, while others were not. This division accounts for much of the evaluative conflict over art like Pissarro's, although not all of it, because there were degrees of dirtiness to be considered by those who acknowledged it as the issue.

Like both Cézanne and Gauguin who learned from him, Pissarro could be dirty in a direct way. He did not hesitate to mix red into green, wet into wet, as in the predominantly green, wooded area at the right of *The Big Pear Tree at Montfoucault*, 1876 (fig. 15). The variations of color in this generously brushed painting—reds within yellows in the field, reds within greens in the forest—do not describe anything unambiguously evident. The redness has no other name. We notice it because it seems to be just the right chromatic force to activate the greater quantities of green, yellow, blue, and white. But what does the red mean? The picture is clearly representational, yet aspects of this deceptively simple "sign" fail to correspond to known aspects of its corresponding "thing." If immediacy of feeling is the artist's concern, such disruption in the chain of reference can be an advantage. Bonded with the paint-ground of his picture, Pissarro's red is pure sensation, pure feeling, a sign not of a thing but of the artist's own wildness or naturalness, his *qualités sauvages*. He understood that painting motivated by direct feeling, as opposed to theoretical and interpretive concerns, is like work undertaken for the well-being that work itself brings to every human life.[33] Alienated from the sign, Pissarro's red is his unalienated work. ❧

Plates

1. *La Roche-Guyon*, 1859
Watercolor and pencil on paper, 11¼ × 15⅛ in. (30 × 40 cm)
Private collection, New York, Courtesy of Stern Pissarro Gallery, London

2. *Inlet and Sailboat*, 1856
Oil on canvas, 13¾ × 20⅞ in. (35 × 53 cm)
Private collection, Courtesy of Michael Connors Antiques, New York, and Sotheby's

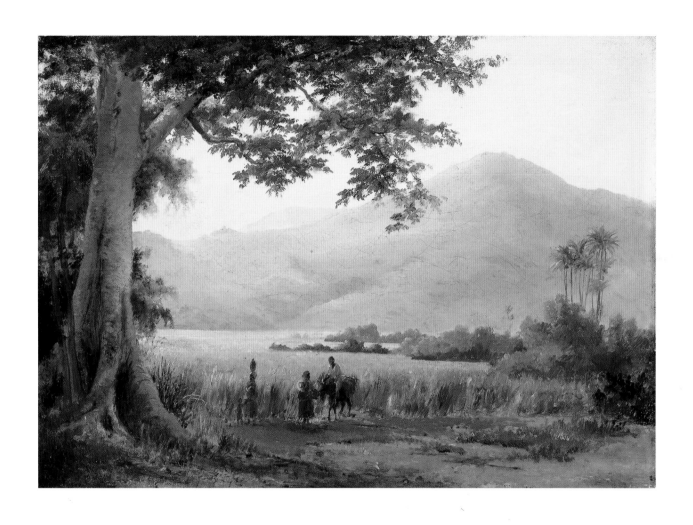

3. *Figures Conversing by a Country Road*, 1856
Oil on canvas, 12¹³⁄₁₆ × 18⅛ in. (32.5 × 46 cm)
Private collection, Courtesy of Michael Connors Antiques, New York, and Sotheby's

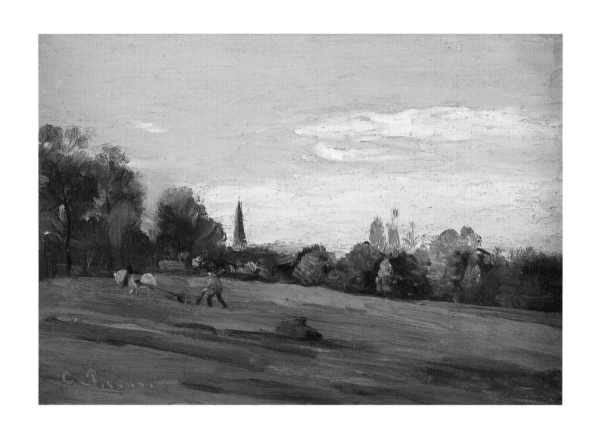

4. *Ploughing, Bérelles,* c. 1860
Oil on panel, 6¼ × 9⅞ in. (17.2 × 25.1 cm)
Collection of Deanne and Arthur Indursky, New York, Courtesy of Sotheby's

5. *Sous bois*, 1862
Black chalk and white highlights on toned paper, 9⁷⁄₁₆ × 7¼ in. (24 × 18.4 cm)
The Hyde Collection, Glens Falls, New York (1971.77)

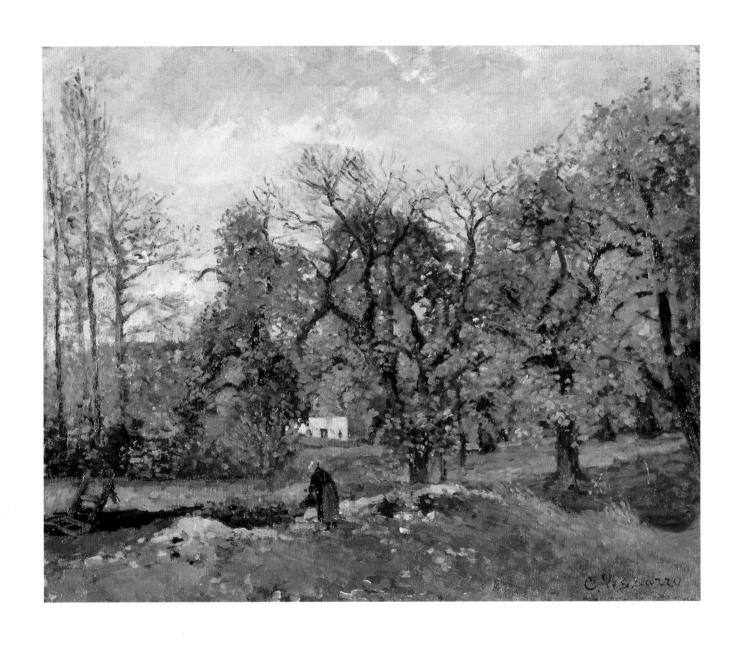

6. *The Brook at Montbuisson, Louveciennes*, c. 1869
Oil on canvas, 18 × 22 in. (45.8 × 55.8 cm)
Private collection, Farmington, Connecticut, Courtesy of Sotheby's

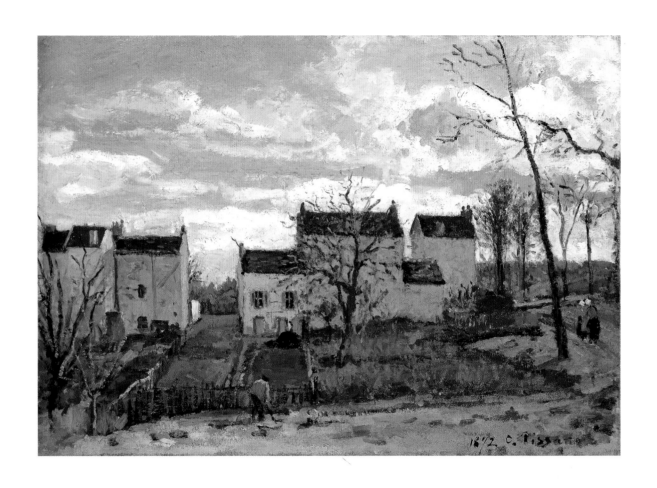

7. *Houses on a Hill, Winter, Near Louveciennes*, 1872
Oil on canvas, 12�¹⁵/₁₆ × 18 in. (32.5 × 45.8 cm)
Private collection, Courtesy of Christie's

8. *Hill at Pontoise*, 1873
Etching, plate: 4⅝ × 6¼ in. (11.8 × 15.9 cm)
Samuel Putnam Avery Collection, Miriam and Ira D. Wallach Division of Art,
Prints and Photographs, The New York Public Library, Astor, Lenox and Tilden Foundations

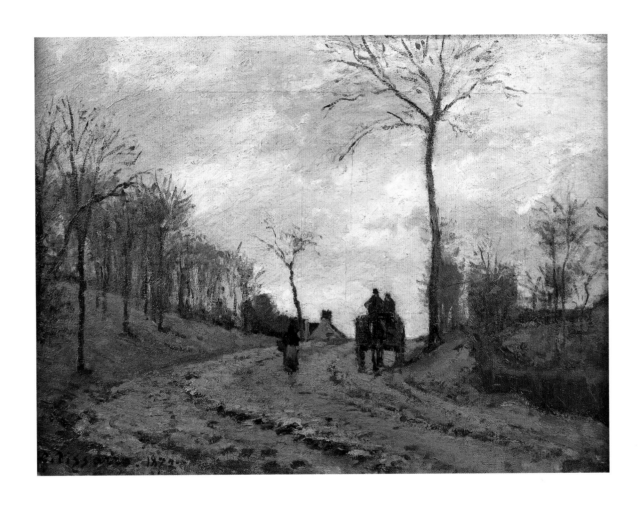

9. Cart on a Road, Near Louveciennes, Winter, 1872
Oil on canvas, 12¾ × 18¾ in. (32.4 × 46.3 cm)
Collection of Jeffrey Steiner

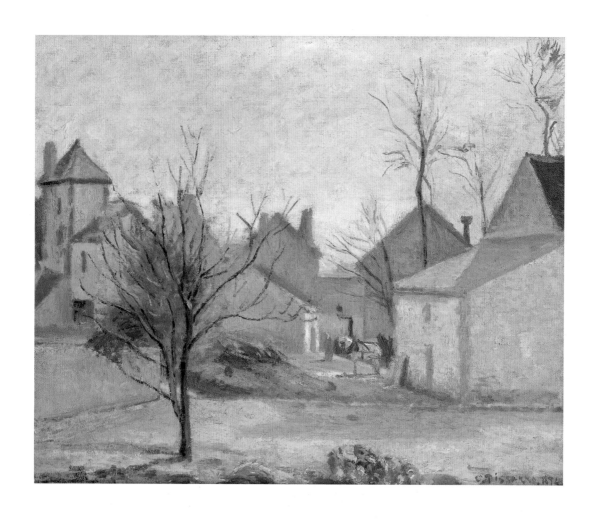

10. *Houses at L'Hermitage, Pontoise,* 1874
Oil on canvas, 14⅝ × 17¾ in. (37 × 45 cm)
Collection of Mr. and Mrs. Jeffrey Peek

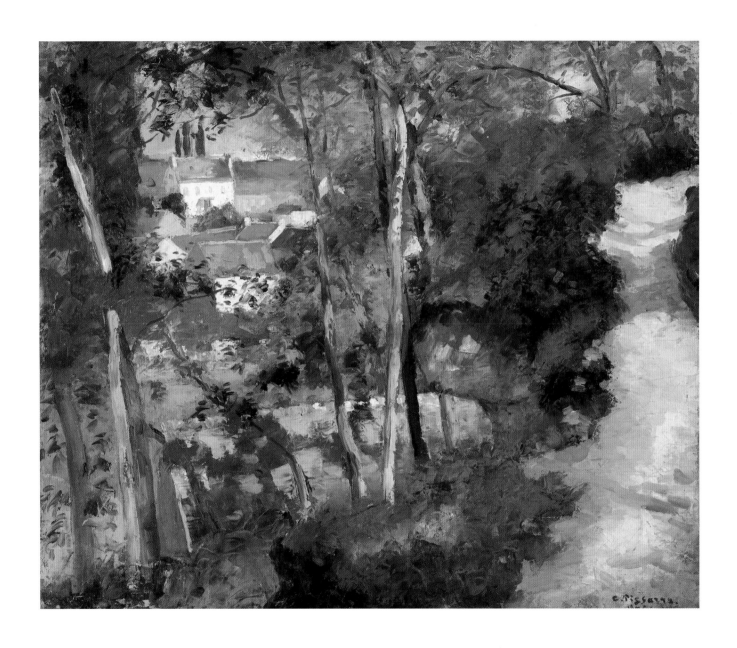

11. *The Climbing Path, L'Hermitage, Pontoise*, 1875
Oil on canvas, 21⅛ × 25¼ in. (53.7 × 65.4 cm)
Brooklyn Museum, Purchased with funds given by Dikran G. Kelekian (22.60)

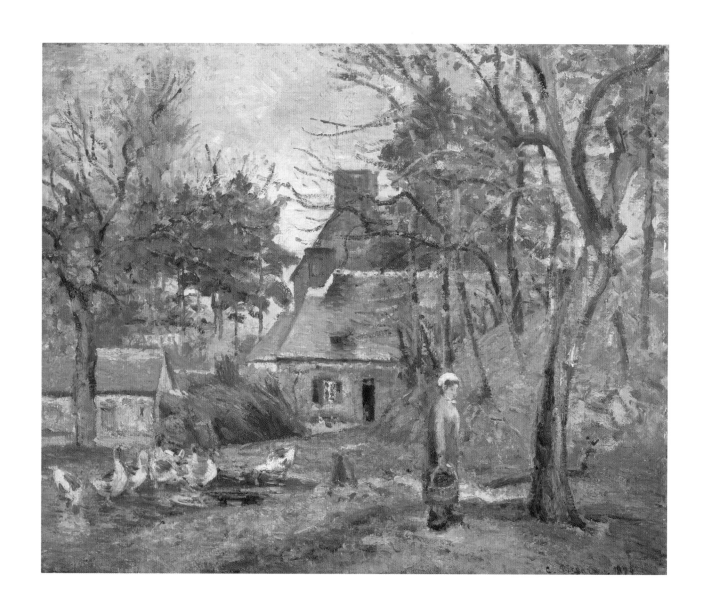

12. *Farm at Montfoucault*, 1874
Oil on canvas, 21½ × 25¼ in. (54.5 × 65.5 cm)
Albright-Knox Art Gallery, Buffalo, New York, Bequest of Miss Gertrude Watson, 1938 (1938:16)

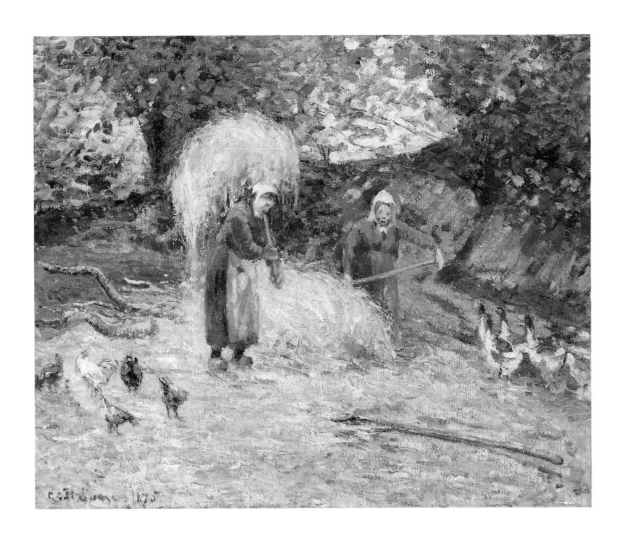

13. *Peasant Women Shifting Straw, Montfoucault*, 1875
Oil on canvas, 18¼ × 22⅛ in. (46.4 × 56.2 cm)
Collection of Francis Belmont

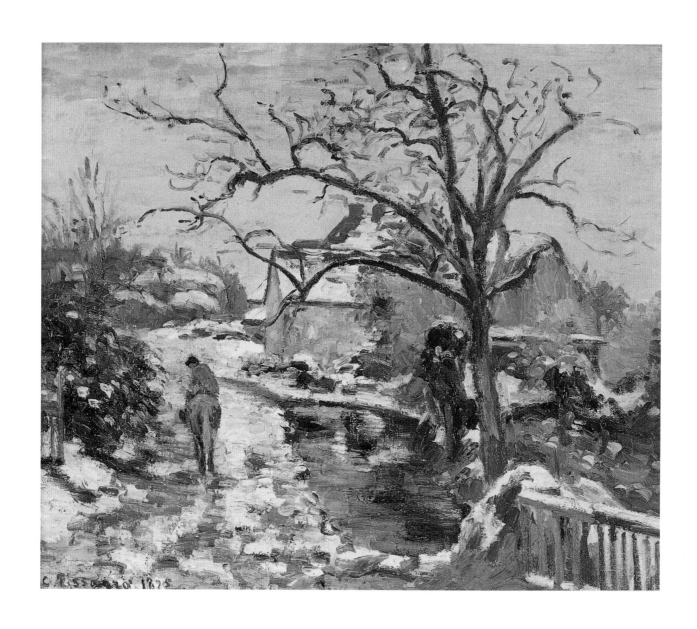

14. *Winter at Montfoucault, Man Riding a Horse,* 1875
Oil on canvas, 18⅛ × 21⅛ in. (46 × 55 cm)
Collection of Michael and Henry Jaglom

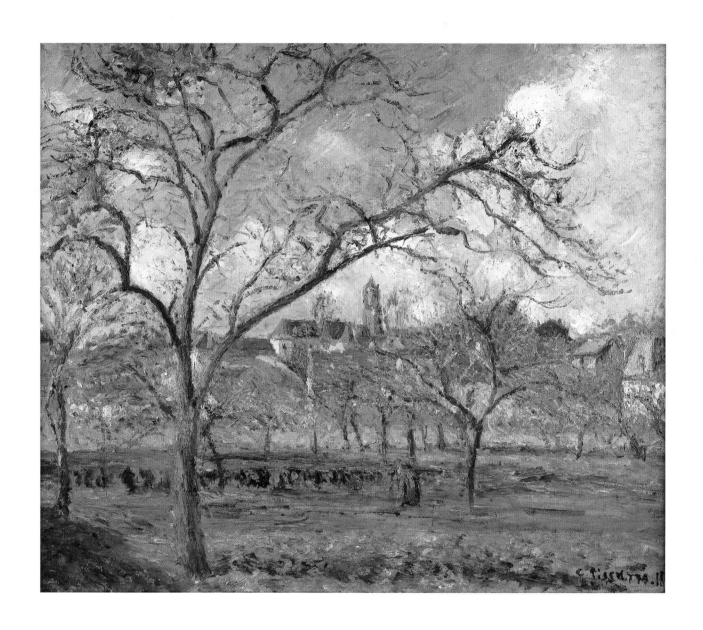

15. *Orchard at Saint-Ouen-l'Aumône in Winter*, 1877
Oil on canvas, 18½ × 22 in. (47 × 56 cm)
Collection of Margaret and Adrian Selby, Courtesy of Christie's

16. *View of Pontoise*, 1885
Etching, seventh state, plate: 6¼ × 9½ in. (15.9 × 24.1 cm)
Samuel Putnam Avery Collection, Miriam and Ira D. Wallach Division of Art, Prints and Photographs,
The New York Public Library, Astor, Lenox and Tilden Foundations

17. *Effect of Rain*, 1879
Etching and aquatint, sixth state, plate: 6¼ × 8⅜ in. (15.9 × 21.1 cm)
Samuel Putnam Avery Collection, Miriam and Ira D. Wallach Division of Art, Prints and Photographs,
The New York Public Library, Astor, Lenox and Tilden Foundations

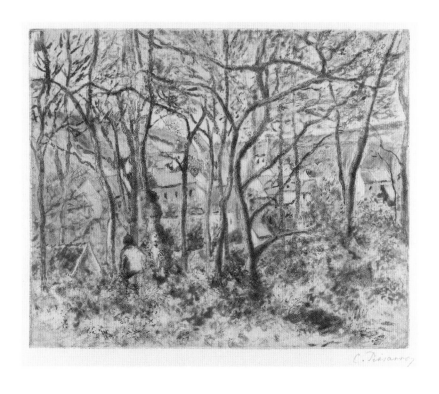

18. *The Woods at L'Hermitage, Pontoise,* 1879
Softground etching, aquatint, and drypoint on china paper, sixth state, plate: 8¹¹⁄₁₆ × 10⁵⁄₈ in. (22 × 26.9 cm)
The Metropolitan Museum of Art, Rogers Fund, 1921 (21.46.1)

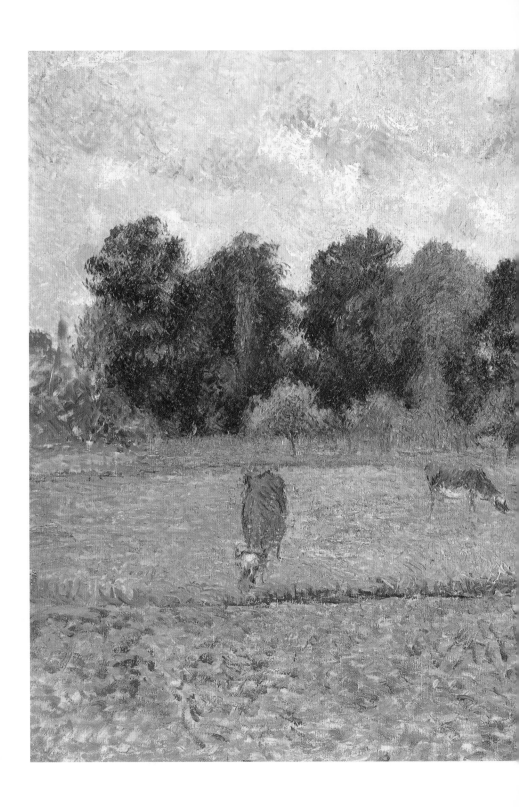

19. *Landscape at Osny, View of the Farm*, c. 1883
Oil on canvas, 30¼ × 49 in. (76.8 × 124.5 cm)
Armand Hammer Foundation

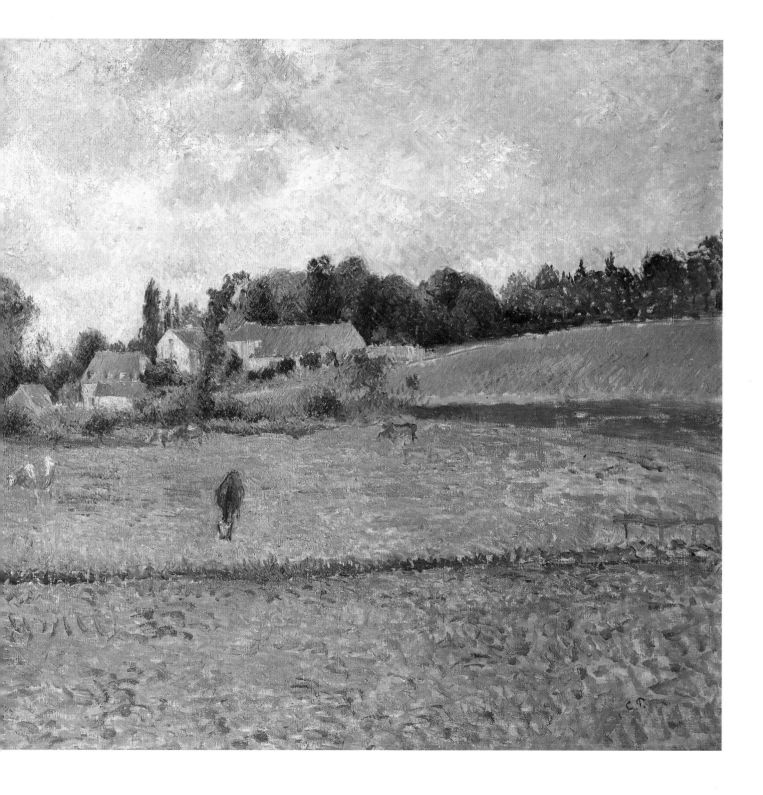

20. *The Château de Busagny, Osny,* 1884
Oil on canvas, 21¼ × 25⅝ in. (54 × 65 cm)
Courtesy of The Art Collection, Inc., Great Neck, New York

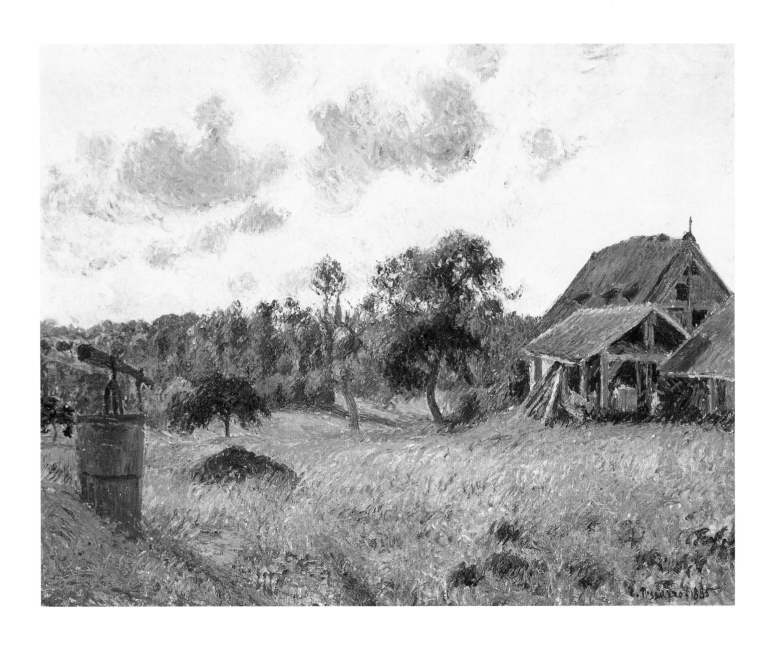

21. *The Delafolie Brickyard, Éragny, Sunset*, 1885
Oil on canvas, 23¼ × 28¼ in. (59 × 73 cm)
Private collection, New York

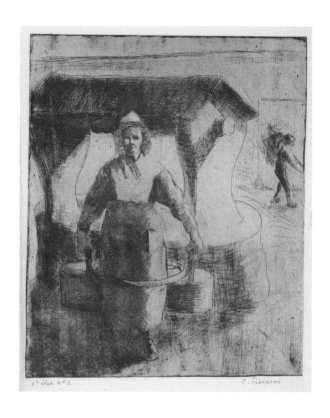

22. *Woman at a Well*, 1891
Etching and aquatint, second state, plate: 9¼ × 7¹¹⁄₁₆ in. (23.5 × 19.5 cm)
The Metropolitan Museum of Art, The Elisha Whittelsey Collection,
The Elisha Whittelsey Fund, 1993 (1993.1055.1)

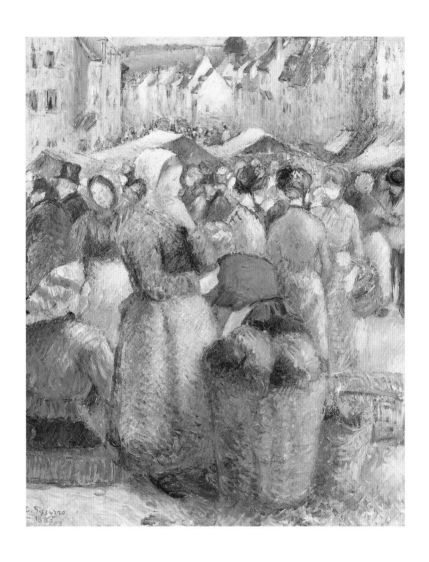

23. *The Market on the Grande-Rue, Gisors*, 1885
Oil on canvas, 18⅛ × 15 in. (46 × 38 cm)
Collection of Mr. and Mrs. Herbert Klapper

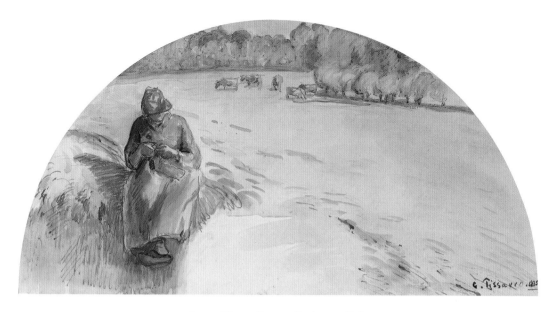

24. *Peasant Woman Knitting (Study for a Fan)*, 1885
Watercolor on fan, 8 × 23⅛ in. (20.3 × 59.7 cm)
Private collection, New York, Courtesy of Stern Pissarro Gallery, London

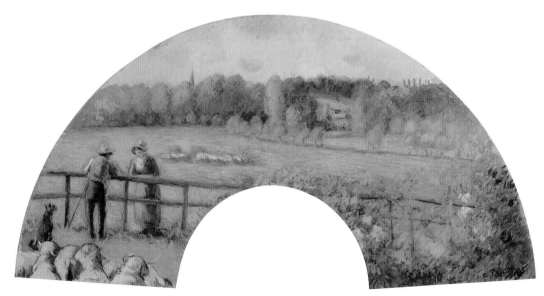

25. *Bazincourt, the Shepherd*, 1885
Gouache on paper fan, 7½ × 23¼ in. (19 × 59 cm)
Private collection, New York

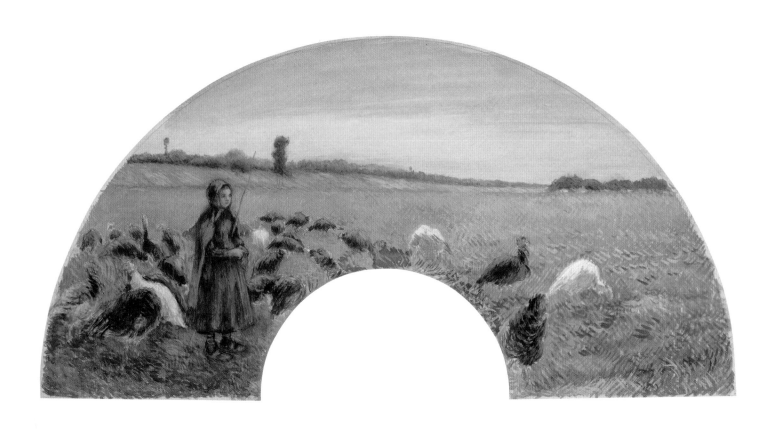

26. *Girl in Field with Turkeys*, 1885
Gouache on silk mounted on paper, 14¾ × 27 in. (37.5 × 68.6 cm)
Brooklyn Museum, Gift of Edwin C. Vogel (59.28)

27. *Ploughing at Éragny*, c. 1886
Oil on panel, 6⅛ × 9¼ in. (15.6 × 23.5 cm)
Private collection, Courtesy of Barbara Divver Fine Art, New York, and Christie's

28. *Landscape at Éragny-sur-Epte*, 1886–88
Watercolor over traces of graphite on paper,
7¼₆ × 9¼₆ in. (18.4 × 23 cm)
Thaw Collection, The Pierpont Morgan Library, New York (EVT 132)

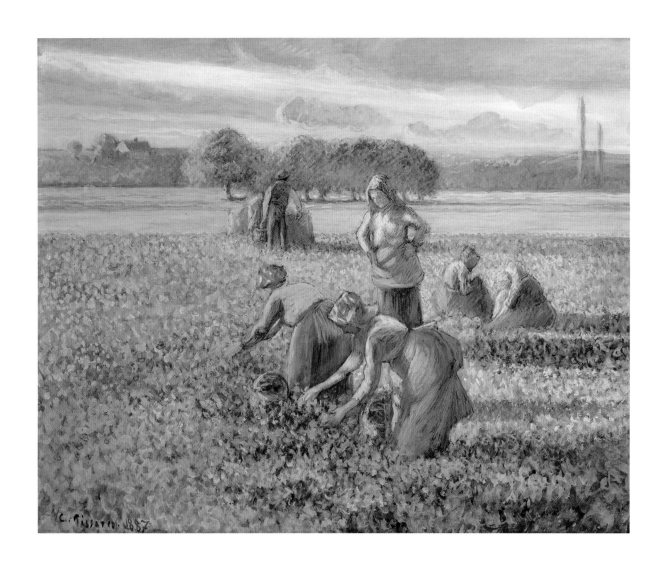

29. *Picking Peas*, 1887
Gouache on paper, 20½ × 24¼ in. (52.1 × 62.9 cm)
Collection of Bruce and Robbi Toll

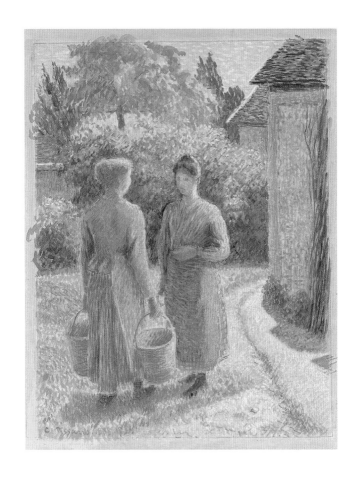

30. *Two Women in a Garden*, 1888
Gouache on silk, 12¹⁵⁄₁₆ × 9¹¹⁄₁₆ in. (32.5 × 24.6 cm)
The Metropolitan Museum of Art, Bequest of Gregoire Tarnopol, 1979,
and Gift of Alexander Tarnopol, 1980 (1980.21.15)

31. *Dockworkers at Rouen*, 1887
Drypoint, plate: 5 × 6¼ in. (12.7 × 17.2 cm)
Samuel Putnam Avery Collection, Miriam and Ira D. Wallach Division of Art, Prints and
Photographs, The New York Public Library, Astor, Lenox and Tilden Foundations

32. *The Port of Rouen*, 1885
Etching, aquatint, and drypoint on laid paper,
second state, plate: 4⁄₁₆ × 4¹⁵⁄₁₆ in. (10.3 × 12.3 cm)
The Metropolitan Museum of Art, Gift of W. L. Andrews, 1917. (17.70.5)

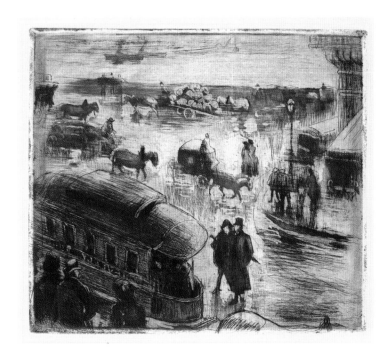

33. *Place de la République at Rouen, with Tramway,* 1883
Etching, second state, plate: 5¾ × 6⅝ in. (14.6 × 16.8 cm)
Samuel Putnam Avery Collection, Miriam and Ira D. Wallach Division of Art, Prints
and Photographs, The New York Public Library, Astor, Lenox and Tilden Foundations

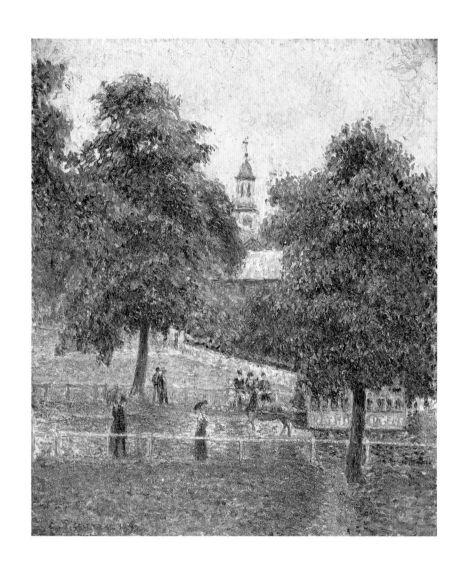

34. *Saint Anne's Church in Kew, London*, 1892
Oil on canvas, 21⅛ × 18⅛ in. (55 × 46 cm)
John C. Whitehead Collection, Courtesy of Achim Moeller Fine Art, New York

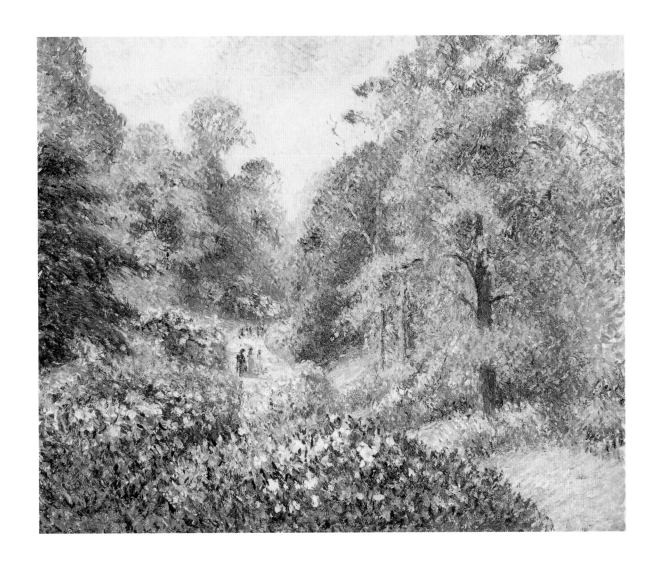

35. *Kew Gardens, London, the Rhododendron Path*, 1892
Oil on canvas, 21¼ × 25⅝ in. (54 × 65 cm)
Private collection, Courtesy of Sotheby's

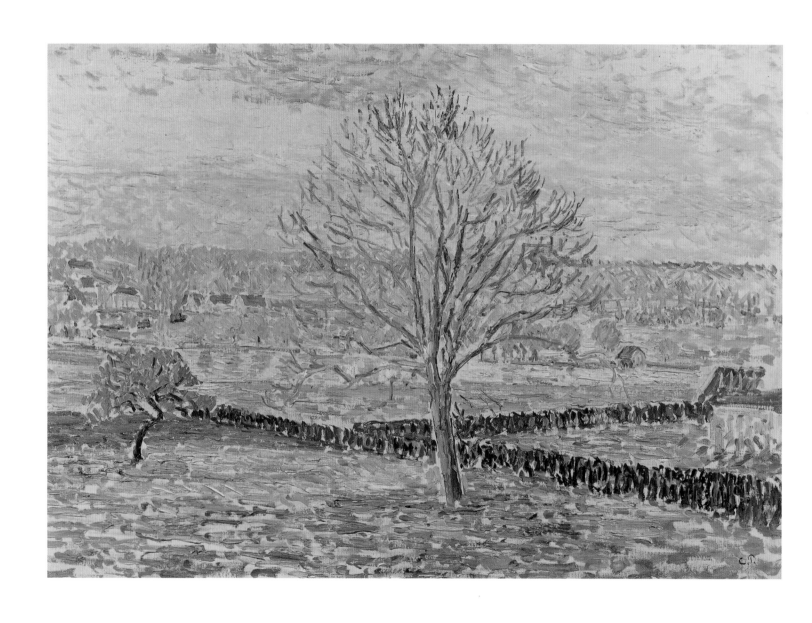

36. *The Big Walnut Tree, Flooding, Sunlight Effect, Éragny,* c. 1892
Oil on canvas, 25⅝ × 36¼ in. (65 × 92 cm)
Private collection

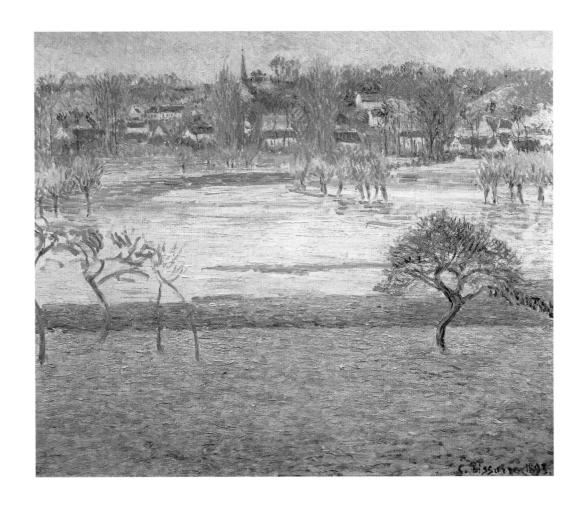

37. *View of Bazincourt, Flood*, 1893
Oil on canvas, 21⅛ × 25⅝ in. (55 × 65 cm)
Courtesy of The Art Collection, Inc., Great Neck, New York

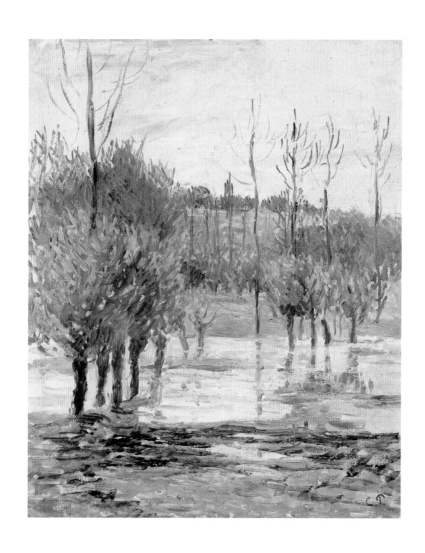

38. *Flood, Éragny*, c. 1893
Oil on canvas, 18⅛ × 15 in. (46 × 38 cm)
Collection of Barbara and Harvey Manes

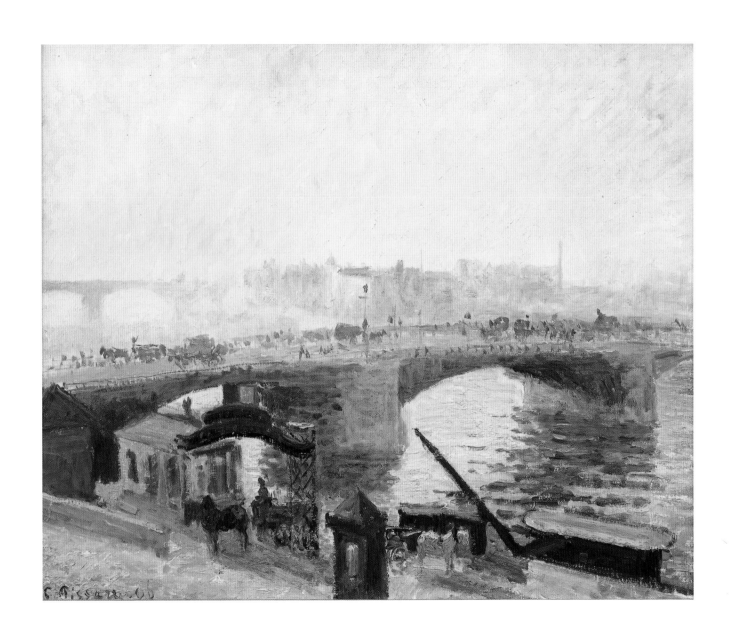

39. *The Pont Boieldieu at Rouen, Effect of Mist*, 1896
Oil on canvas, 19⅝ × 24 in. (50 × 61 cm)
Private collection

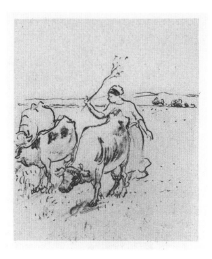

40. *Peasant Woman Herding Cows*, c. 1899
Lithograph, trial proof, plate: 5⅛ × 4⅜ in. (13 × 11.1 cm)
Samuel Putnam Avery Collection, Miriam and Ira D. Wallach
Division of Art, Prints and Photographs, The New York Public
Library, Astor, Lenox and Tilden Foundations

41. *Landscape*, c. 1890–95
Watercolor and charcoal on paper, laid down on card, 4¼ × 10⅛ in. (10.8 × 25.7 cm)
Collection of Deanne and Arthur Indursky, New York

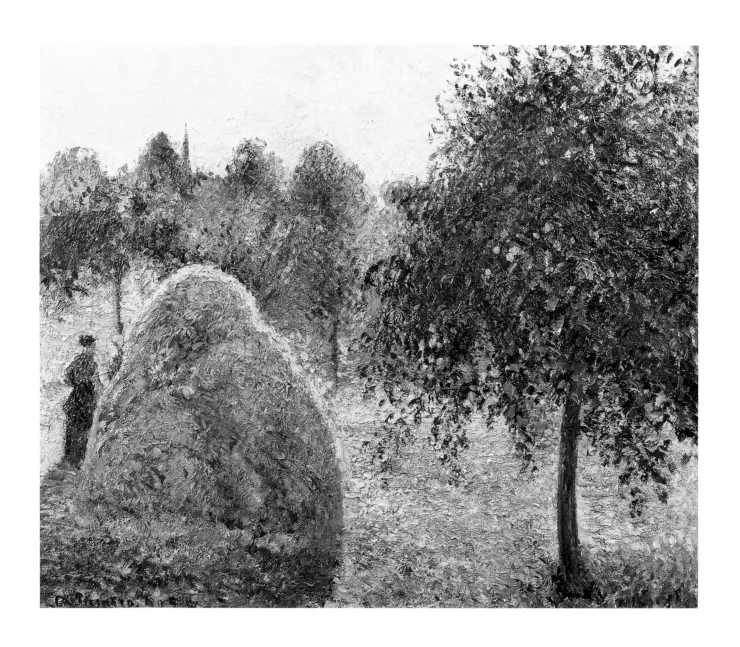

42. *The Haystack, Sunset, Éragny*, 1895
Oil on canvas, 21¼ × 25⅛ in. (54 × 65 cm)
Collection of Mr. and Mrs. Joseph Wilf, New York

43. *Carriages on the Boulevard Montmartre*, 1897
Ink and sepia wash on paper, 6¼ × 8⅜ in. (17.1 × 21.9 cm)
John C. Whitehead Collection, Courtesy of Achim Moeller Fine Art, New York

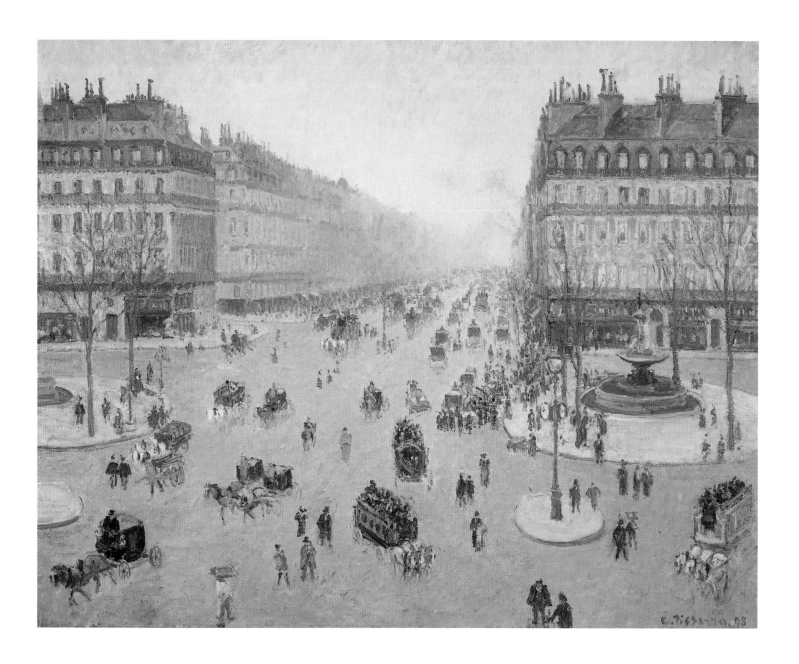

44. *Place du Théâtre-Français and the Avenue de l'Opéra, Hazy Weather*, 1898
Oil on canvas, 29⅛ × 36 in. (74 × 91.5 cm)
Collection of Mr. and Mrs. Herbert Klapper

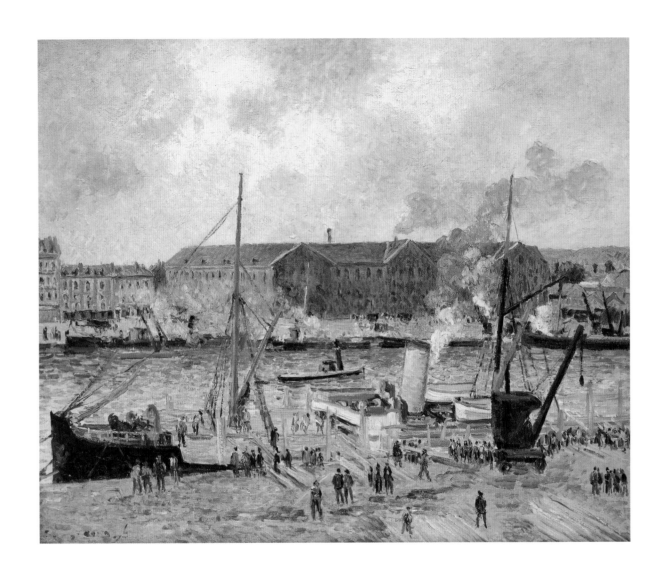

45. *The Wharves, Saint-Sever, Rouen,* 1896
Oil on canvas, 21¼ × 25⅝ in. (54 × 65.1 cm)
Collection of Bruce and Robbi Toll

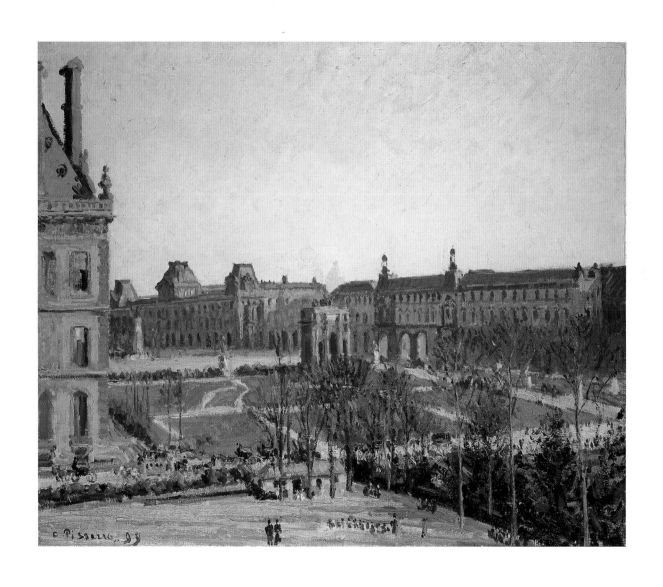

46. *The Louvre and the Carrousel Garden, Sunlight, Afternoon*, 1899
Oil on canvas, 21¼ × 25⅝ in. (54 × 65 cm)
Private collection

47. *Apple Trees in Bloom, Éragny*, c. 1900
Oil on panel, 8⅜ × 10⁹⁄₁₆ in. (21.1 × 26.8 cm)
John C. Whitehead Collection, Courtesy of Achim Moeller Fine Art, New York

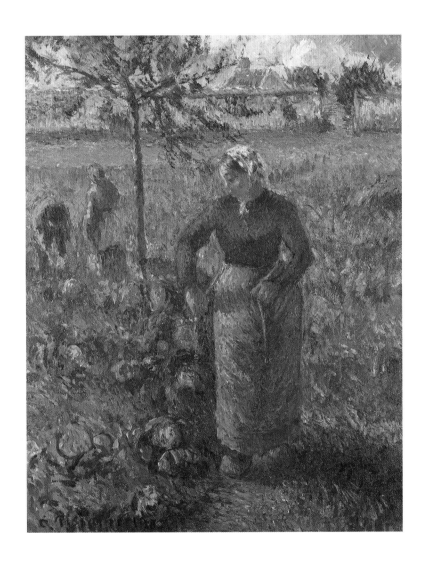

48. *Peasant Woman in a Cabbage Patch, Éragny*, 1901–2
Oil on canvas, 16⅛ × 13 in. (41 × 33 cm)
Collection of Bettina L. Decker

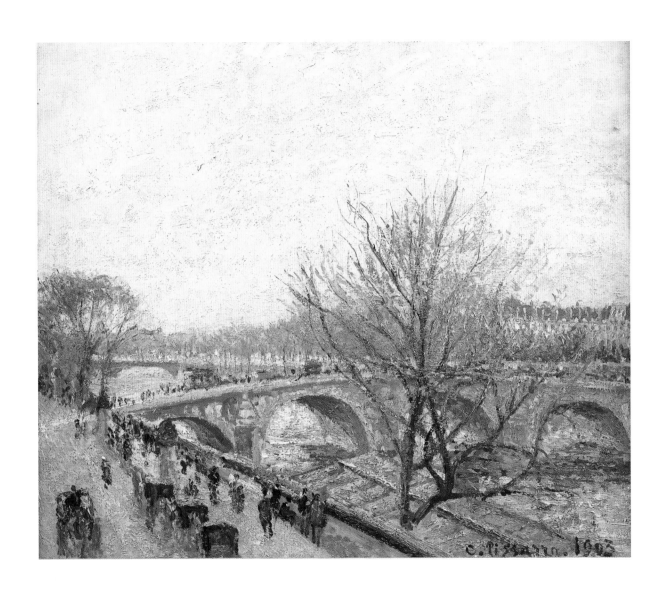

49. *The Pont-Royal, Bright Cloudy Weather (Fourth Series)*, 1903
Oil on canvas, 21¼ × 25⅜ in. (54.6 × 64.4 cm)
Collection of Simone and Alan Hartman

Figures Conversing by a Country Road, 1856
Oil on canvas, 12⅞ × 18⅛ in. (32.5 × 46 cm)
Private collection, Courtesy of Michael Connors
Antiques, New York, and Sotheby's
Plate 3

Inlet and Sailboat, 1856
Oil on canvas, 13¾ × 20⅞ in. (35 × 53 cm)
Private collection, Courtesy of Michael Connors
Antiques, New York, and Sotheby's
Plate 2

La Roche-Guyon, 1859
Watercolor and pencil on paper, 11¾ × 15¾ in. (30 × 40 cm)
Private collection, New York, Courtesy of Stern Pissarro
Gallery, London
Plate 1

Ploughing, Bérelles, c. 1860
Oil on panel, 6¾ × 9⅞ in. (17.2 × 25.1 cm)
Collection of Deanne and Arthur Indursky, New York,
Courtesy of Sotheby's
Plate 4

Sous bois, 1862
Black chalk and white highlights on toned paper, 9½ ×
7¼ in. (24 × 18.4 cm)
The Hyde Collection, Glens Falls, New York (1971.77)
Plate 5

The Brook at Montbuisson, Louveciennes, c. 1869
Oil on canvas, 18 × 22 in. (45.8 × 55.8 cm)
Private collection, Farmington, Connecticut, Courtesy
of Sotheby's
Plate 6

Houses on a Hill, Winter, Near Louveciennes, 1872
Oil on canvas, 12⅞ × 18 in. (32.5 × 45.8 cm)
Private collection, Courtesy of Christie's
Plate 7

Cart on a Road, Near Louveciennes, Winter, 1872
Oil on canvas, 12¾ × 18¼ in. (32.4 × 46.3 cm)
Collection of Jeffrey Steiner
Plate 9

Hill at Pontoise, 1873
Etching, plate: 4⅝ × 6¼ in. (11.8 × 15.9 cm)
Samuel Putnam Avery Collection, Miriam and Ira D.
Wallach Division of Art, Prints and Photographs,

The New York Public Library, Astor, Lenox and
Tilden Foundations
Plate 8

Houses at L'Hermitage, Pontoise, 1874
Oil on canvas, 14½ × 17¾ in. (37 × 45 cm)
Collection of Mr. and Mrs. Jeffrey Peek
Plate 10

Farm at Montfoucault, 1874
Oil on canvas, 21½ × 25¾ in. (54.5 × 65.5 cm)
Albright-Knox Art Gallery, Buffalo, New York,
Bequest of Miss Gertrude Watson, 1938 (1938:16)
Plate 12

The Climbing Path, L'Hermitage, Pontoise, 1875
Oil on canvas, 21½ × 25¾ in. (53.7 × 65.4 cm)
Brooklyn Museum, Purchased with funds
given by Dikran G. Kelekian (22.60)
Plate 11

Peasant Women Shifting Straw, Montfoucault, 1875
Oil on canvas, 18¼ × 22⅛ in. (46.4 × 56.2 cm)
Collection of Francis Belmont
Plate 13

Winter at Montfoucault, Man Riding a Horse, 1875
Oil on canvas, 18⅛ × 21⅝ in. (46 × 55 cm)
Collection of Michael and Henry Jaglom
Plate 14

Orchard at Saint-Ouen-l'Aumône in Winter, 1877
Oil on canvas, 18½ × 22 in. (47 × 56 cm)
Collection of Margaret and Adrian Selby, Courtesy of
Christie's
Plate 15

The Woods at L'Hermitage, Pontoise, 1879
Softground etching, aquatint, and drypoint on china
paper, sixth state, plate: 8⅝ × 10⅝ in. (22 × 26.9 cm)
The Metropolitan Museum of Art, Rogers Fund,
1921 (21.46.1)
Plate 18

Effect of Rain, 1879
Etching and aquatint, sixth state, plate: 6¼ × 8⅜ in.
(15.9 × 21.1 cm)
Samuel Putnam Avery Collection, Miriam and Ira D.
Wallach Division of Art, Prints and Photographs,
The New York Public Library, Astor, Lenox and Tilden
Foundations
Plate 17

Landscape at Osny, View of the Farm, c. 1883
Oil on canvas, 30¼ × 49 in. (76.8 × 124.5 cm)
Armand Hammer Foundation
Plate 19

Place de la République at Rouen, with Tramway, 1883
Etching, second state, plate: 5¾ × 6⅝ in. (14.6 × 16.8 cm)
Samuel Putnam Avery Collection, Miriam and Ira D.
Wallach Division of Art, Prints and Photographs,
The New York Public Library, Astor, Lenox and
Tilden Foundations
Plate 33

The Château de Busagny, Osny, 1884
Oil on canvas, 21¼ × 25¾ in. (54 × 65 cm)
Courtesy of The Art Collection, Inc., Great Neck,
New York
Plate 20

The Port of Rouen, 1885
Etching, aquatint, and drypoint on laid paper,
second state, plate: 4⅛ × 4⅞ in. (10.3 × 12.3 cm)
The Metropolitan Museum of Art, Gift of W. L.
Andrews, 1917. (17.70.5)
Plate 32

The Delafolie Brickyard, Éragny, Sunset, 1885
Oil on canvas, 23¼ × 28¾ in. (59 × 73 cm)
Private collection, New York
Plate 21

The Market on the Grande-Rue, Gisors, 1885
Oil on canvas, 18⅛ × 15 in. (46 × 38 cm)
Collection of Mr. and Mrs. Herbert Klapper
Plate 23

Peasant Woman Knitting (Study for a Fan), 1885
Watercolor on fan, 8 × 23½ in. (20.3 × 59.7 cm)
Private collection, New York, Courtesy of Stern
Pissarro Gallery, London
Plate 24

Bazincourt, the Shepherd, 1885
Gouache on paper fan, 7½ × 23¼ in. (19 × 59 cm)
Private collection, New York
Plate 25

Girl in Field with Turkeys, 1885
Gouache on silk mounted on paper,
14¾ × 27 in. (37.5 × 68.6 cm)
Brooklyn Museum, Gift of Edwin C. Vogel (59.28)
Plate 26

View of Pontoise, 1885
Etching, seventh state, plate: 6¼ × 9½ in. (15.9 × 24.1 cm)
Samuel Putnam Avery Collection, Miriam and Ira D.
Wallach Division of Art, Prints and Photographs,
The New York Public Library, Astor, Lenox and
Tilden Foundations
Plate 16

Ploughing at Éragny, c. 1886
Oil on panel, 6¼ × 9¼ in. (15.6 × 23.5 cm)
Private collection, Courtesy of Barbara Divver Fine Art,
New York, and Christie's
Plate 27

Landscape at Éragny-sur-Epte, 1886–88
Watercolor over traces of graphite on paper,
7¼ × 9⅛ in. (18.4 × 23 cm)
Thaw Collection, The Pierpont Morgan Library,
New York (EVT 132)
Plate 28

Picking Peas, 1887
Gouache on paper, 20½ × 24¾ in. (52.1 × 62.9 cm)
Collection of Bruce and Robbi Toll
Plate 29

Dockworkers at Rouen, 1887
Drypoint, plate: 5 × 6¾ in. (12.7 × 17.2 cm)
Samuel Putnam Avery Collection, Miriam and Ira D.
Wallach Division of Art, Prints and Photographs,
The New York Public Library, Astor, Lenox and
Tilden Foundations
Plate 31

Two Women in a Garden, 1888
Gouache on silk, 12⅞ × 9¾ in. (32.5 × 24.6 cm)
The Metropolitan Museum of Art, Bequest of Gregoire
Tarnopol, 1979, and Gift of Alexander Tarnopol, 1980
(1980.21.15)
Plate 30

Woman at a Well, 1891
Etching and aquatint, second state, plate: 9¼ × 7⅝ in.
(23.5 × 19.5 cm)
The Metropolitan Museum of Art, The Elisha
Whittelsey Collection, The Elisha Whittelsey Fund,
1993 (1993.1055.1)
Plate 22

Saint Anne's Church in Kew, London, 1892
Oil on canvas, 21⅝ × 18⅛ in. (55 × 46 cm)
John C. Whitehead Collection, Courtesy of Achim
Moeller Fine Art, New York
Plate 34

Kew Gardens, London, the Rhododendron Path, 1892
Oil on canvas, 21¼ × 25⅝ in. (54 × 65 cm)
Private collection, Courtesy of Sotheby's
Plate 35

The Big Walnut Tree, Flooding, Sunlight Effect, Éragny,
c. 1892
Oil on canvas, 25⅝ × 36¼ in. (65 × 92 cm)
Private collection
Plate 36

View of Bazincourt, Flood, 1893
Oil on canvas, 21⅝ × 25⅝ in. (55 × 65 cm)
Courtesy of The Art Collection, Inc., Great Neck,
New York
Plate 37

Flood, Éragny, c. 1893
Oil on canvas, 18⅛ × 15 in. (46 × 38 cm)
Collection of Barbara and Harvey Manes
Plate 38

Landscape, c. 1890–95
Watercolor and charcoal on paper, laid down on card,
4¼ × 10⅛ in. (10.8 × 25.7 cm)
Collection of Deanne and Arthur Indursky, New York
Plate 41

The Haystack, Sunset, Éragny, 1895
Oil on canvas, 21¼ × 25⅝ in. (54 × 65 cm)
Collection of Mr. and Mrs. Joseph Wilf, New York
Plate 42

The Pont Boieldieu at Rouen, Effect of Mist, 1896
Oil on canvas, 19⅝ × 24 in. (50 × 61 cm)
Private collection
Plate 39

The Wharves, Saint-Sever, Rouen, 1896
Oil on canvas, 21¼ × 25⅝ in. (54 × 65.1 cm)
Collection of Bruce and Robbi Toll
Plate 45

Carriages on the Boulevard Montmartre, 1897
Ink and sepia wash on paper, 6¾ × 8⅝ in. (17.1 × 21.9 cm)

John C. Whitehead Collection, Courtesy of Achim
Moeller Fine Art, New York
Plate 43

*Place du Théâtre-Français and the Avenue de l'Opéra,
Hazy Weather*, 1898
Oil on canvas, 29⅛ × 36 in. (74 × 91.5 cm)
Collection of Mr. and Mrs. Herbert Klapper
Plate 44

*The Louvre and the Carrousel Garden, Sunlight,
Afternoon*, 1899
Oil on canvas, 21¼ × 25⅝ in. (54 × 65 cm)
Private collection
Plate 46

Peasant Woman Herding Cows, c. 1899
Lithograph, trial proof, plate: 5⅛ × 4⅜ in. (13 × 11.1 cm)
Samuel Putnam Avery Collection, Miriam and Ira D.
Wallach Division of Art, Prints and Photographs,
The New York Public Library, Astor, Lenox and
Tilden Foundations
Plate 40

Apple Trees in Bloom, Éragny, c. 1900
Oil on panel, 8⅜ × 10⅝ in. (21.1 × 26.8 cm)
John C. Whitehead Collection, Courtesy of Achim
Moeller Fine Art, New York
Plate 47

Peasant Woman in a Cabbage Patch, Éragny, 1901–2
Oil on canvas, 16⅛ × 13 in. (41 × 33 cm)
Collection of Bettina L. Decker
Plate 48

*The Pont-Royal, Bright Cloudy Weather
(Fourth Series)*, 1903
Oil on canvas, 21½ × 25⅜ in. (54.6 × 64.4 cm)
Collection of Simone and Alan Hartman
Plate 49

Levitov
PATHS TO PISSARRO

1. These villages include Chennevières-sur-Marne, La Varenne-St-Hilaire, Bougival, Louveciennes, Marly, Maubuisson, L'Isle-Adam, Pontoise, Osny, Ennery, Auvers-sur-Oise, Gisors, and Éragny-sur-Ept. See Terence Maloon, ed., *Camille Pissarro* (Sydney: Art Gallery of New South Wales, 2005), 218–19.

2. Although more than once, Pissarro was forced to move his family due to economic hardships or political circumstances, such as the Franco-Prussian War (1870–71).

3. Joachim Pissarro compellingly suggests that Pissarro's parents' distinctly modern challenge to the authority of the religious institution is paradoxically analogous to their son's later stance against the French art establishment. In the former case, the struggle is to remain within the institution; in the latter case, the son made a radical break with the establishment. See Joachim Pissarro, *Pioneering Modern Painting: Cézanne and Pissarro, 1865–1885* (New York: Museum of Modern Art, 2005), 17. For more on Pissarro's Jewish background and identity, see Stephanie Rachum, "Pissarro's Jewish Identity,"*ASSAPH–Studies in Art History* 5 (2000): 3–28; Joachim Pissarro and Stephanie Rachum, *Camille Pissarro: Impressionist Innovator* (Jerusalem: The Israel Museum, 1994); and Nicholas Mirzoeff, "Pissarro's Passage: The Sensation of Caribbean Jewishness in Diaspora," in Mirzoeff, ed., *Diaspora and Visual Culture: Representing Africans and Jews* (London: Routledge, 2000), 57–75.

4. For a good discussion of the French social climate of Pissarro's time, see Richard Thomson, *Camille Pissarro: Impressionism, Landscape and Rural Labor* (New York: New Amsterdam Books, 1990).

5. Jean-Baptiste-Camille Corot, notebook entry, c. 1855, reprinted in Charles Harrison and Paul Wood with Jason Gaiger, eds., *Art in Theory 1815–1900: An Anthology of Changing Ideas* (Oxford: Blackwell Publishers, 1998), 535.

6. Although seemingly in the tradition of European romanticized depictions of non-Europeans, Pissarro's depictions of these subjects, because of his Caribbean upbringing and education among descendents of slaves, do not exoticize them.

7. Émile Zola first takes notice of Pissarro's work in the 1866 Salon, when Pissarro was still relatively unknown. Zola wrote, "Your landscape refreshed me for a good half-hour in the great desert of the Salon." Quoted in Terence Maloon and Claire Durand-Ruel Snollaerts, "Pissarro and His Critics," in Maloon, ed., *Camille Pissarro*, 228.

8. Camille Pissarro, *Letters to His Son Lucien*, ed. John Rewald and Lucien Pissarro, trans. Lionel Abel (New York: Pantheon, 1943; repr., Boston: Museum of Fine Arts Publications, 2002), Osny, June 13, 1883, 35.

9. Pissarro, *Letters to His Son Lucien*, September 9, 1892, 202.

10. Émile Zola, "The Moment in Art," *Mon Salon*, May 4, 1866, reprinted in Harrison et al., *Art in Theory 1815–1900*, 552.

11. Pissarro, *Letters to His Son Lucien*, Paris, April 20, 1891, 164.

12. Pierre-Joseph Proudhon, *The Principle of Art*, 1865, reprinted in Harrison et al., *Art in Theory 1815–1900*, p. 405.

13. Pissarro, *Letters to His Son Lucien*, Rouen, November 20, 1883, 47.

14. Pissarro, *Letters to His Son Lucien*, Eragny, [May 31, 1887], 113.

15. In addition to being an artist, Piette was a municipal councillor elected on the liberal-conservative platform who then shifted to radical republicanism, according to Thomson, *Camille Pissarro*.

16. Pissarro, as recalled by Octave Mirbeau in "Vincent van Gogh" (1901), "Préface au Catalogue des oeuvres de Camille Pissarro, exposés chez Durand-Ruel du 7 au 30 avril 1904," *Des artistes*, 2:146-47, 226. Quoted in Maloon, ed., *Camille Pissarro*, 249; and in Richard Shiff, "The Restless Worker," in Maloon, ed., *Camille Pissarro*, 40.

17. Shiff, "The Restless Worker," 43.

18. Anonymous, *The Churchman*, New York, 12 June 1886. Quoted in Maloon and Durand-Ruel Snollaerts, "Pissarro and His Critics," 239.

19. F. A. Bridgman, *L'Anarchie dans l'art*. Quoted in Maloon and Durand-Ruel Snollaerts, "Pissarro and his Critics," 240.

20. Pissarro, *Letters to His Son Lucien*, December 28, 1883, 50.

21. See Joachim Pissarro, *Pioneering Modern Painting*.

22. Each artist had already been making prints independently for over a decade. Barbara Stern Shapiro notes that Pissarro made over 200 plates beginning in 1863. For an informative essay on Pissarro's prints, see her "Pissarro as Print-Maker" in *Pissarro: Camille Pissarro 1830–1903* (Boston: Museum of Fine Arts, 1981).

23. Shapiro, *Pissarro*, 192. See also Michel Melot, "A Rebel's Role: Concerning the Prints of Camille Pissarro," in Christopher Lloyd, ed., *Studies on Camille Pissarro* (London and New York: Routledge and Kegan Paul, 1986), 117–22; and Peter Raissis, "Pissarro and Printmaking: An Introduction," in Maloon, ed., *Camille Pissarro*.

24. However, Pissarro's prints did not sell particularly well, as he notes in a letter to his son: "What a pity there is no demand for my prints, I find this work as interesting as painting, everybody does, and there are so few who achieve something in engraving," Pissarro, *Letters to His Son Lucien*, 375.

25. See Joachim Pissarro, "Pissarro's Neo-Impressionism," in Maloon, ed., *Camille Pissarro*, 56.

26. Quoted in ibid., 48.

27. At this time he also met Vincent van Gogh and showed his work with Theo van Gogh.

28. Seurat did not necessarily fit this characteristic of the other artists.

29. Félix Fénéon, "Neo-Impressionism," *L'Art moderne*, Brussels, May 1, 1887, reprinted in Harrison et al., *Art in Theory 1815–1900*, 969.

30. Pissarro, *Letters to His Son Lucien*, Paris, April 13, 1891, 163. The current trend he refers to is Symbolism. Pissarro mentored Paul Gauguin, but they grew apart as Gauguin became interested in Symbolism, which Pissarro found to be sentimental and antinaturalistic.

31. Alexandre Georget, "Exposition International de Peinture," *L'Echo de Paris*, May 17, 1886. Quoted in Malooon and Durand-Ruel Snollaerts, "Pissarro and His Critics," 240.

32. Pissarro, *Letters to His Son Lucien*, 130–31.

33. Pissarro, *Letters to His Son Lucien*, Rouen, October 11, 1883, 40.

34. Pissarro, *Letters to His Son Lucien*, 134–35.

35. In an essay entitled "Pissarro's Passage," Nicholas Mirzoeff associates the artist's "passage" with diaspora, movement, color theory, and the idea of passing unseen as a Jew. See Mirzoeff, *Diaspora and Visual Culture*, 73.

36. Pissarro, *Letters to His Son Lucien*, Paris, September 6, 1888, 131–32. His immediate course of action is to go to the Louvre to gain inspiration from the work of other artists that he finds interesting from this point of view (although he laments that there are no Turners in the Louvre).

37. Richard Brettell, "Camille Pissarro and Urban View Painting: An Introduction," in Brettell and Joachim Pissarro, *The Impressionist and the City: Pissarro's Series Paintings* (New Haven: Yale University Press, 1992), xviii–xxviii. Brettell also suggests these reasons: Pis-

sarro's indignation over the Dreyfus Affair, his interest in urban caricature, a visit to London's National Gallery where he would have viewed Canaletto's famed cityscapes, and his interest in Japanese prints depicting aspects of the modern world.

38. Brettell and Pissarro explicate a correlation between Pissarro's Avenue de l'Opera series and the Dreyfus Affair, based on his reference to both events in letters of this time. See Brettell and Pissarro, *The Impressionist and the City*, 79–82. For more on visual responses to the Dreyfus Affair, see Norman L. Kleeblatt, ed., *The Dreyfus Affair: Art, Truth, and Justice* (Berkeley: University of California Press, 1987).

39. Pissarro, *Letters to His Son Lucien*, Paris, 111 Rue Saint-Lazare, December 15, 1897, 316.

40. Pissarro, *Letters to His Son Lucien*, Éragny, November 14, 1897, 314.

41. Pissarro, *Letters to His Son Lucien*, Paris, January 13, 1898, 318 [letter to Pissarro's niece Esther].

42. Pissarro, *Letters to His Son Lucien*, Paris, November 19, 1898, 332.

43. Pissarro, *Letters to His Son Lucien*, Paris, January 27, 1899, 320.

44. See Linda Nochlin, "Degas and the Dreyfus Affair: A Portrait of the Artist as an Anti-Semite," in Kleeblatt, ed., *The Dreyfus Affair*; and Ralph E. Shikes, "Pissarro's Political Philosophy and His Art" in Lloyd, ed., *Studies on Camille Pissarro*.

45. Brettell, "Camille Pissarro and Urban View Painting," in Brettell and Pissarro, *The Impressionist and*

the City, xxvii.

46. Pissarro, *Letters to His Son Lucien*, Le Havre, July 6, 1903, 357.

Shiff
PISSARRO: DIRTY PAINTER

1. On this event, see Claire Durand-Ruel Snollaerts, "A Painter and His Dealer: Camille Pissarro (1830–1903) and Paul Durand-Ruel (1831–1922)," in Joachim Pissarro and Claire Durand-Ruel Snollaerts, *Pissarro: Critical Catalogue of Paintings*, 3 vols. (Paris: Wildenstein Institute, 2005), 1:51. I thank Catherine Dossin and Caitlin Haskell for essential aid in research. All translations are mine unless otherwise indicated.

2. Octave Mirbeau, "Camille Pissarro," *Catalogue de l'exposition de l'oeuvre de Camille Pissarro* (Paris: Galeries Durand-Ruel, 1904), 3. For an account of the relationship between Pissarro and Mirbeau, see Pierre Michel and Jean-François Nivet, eds., *Octave Mirbeau: Correspondance avec Camille Pissarro* (Tusson: Du Lérot, 1990), 7–22. Concerning the timing of their first meeting—probably 1885, but this is not certain—see Michel and Nivet, *Octave Mirbeau*, 9; and Janine Bailly-Herzberg, ed., *Correspondance de Camille Pissarro*, 5 vols. (Paris: Presses Universitaires de France [vol. 1]; Valhermeil [vols. 2–5], 1980–91), 1:335, note 3.

3. Mirbeau, "Camille Pissarro" (1904), 2, 8.

4. On Pissarro's concern to distance himself from Millet, see his letters to Théodore Duret, March 12, 1882; Lucien Pissarro, May 2, 1887; and Georges Pissarro, December 17, 1889, *Correspondance de Camille Pissarro*, 1: 158, 2:157, 313.

5. Octave Mirbeau, "Camille Pissarro," *L'art dans les deux mondes*, January 10, 1890, 84. Charles Morice adopted the same metaphor although not necessarily to the same end, because he considered Pissarro's pantheism just as conventional for its time as Millet's romantic sentimentalism was for an earlier generation: "[Pissarro's peasants] are neither men nor women, but other cabbages and greens." Charles Morice, "Deux morts: Whistler, Pissarro," *Mercure de France* 49 (April 1904): 95. On the theatricality of Millet (relative to Pissarro), see also Henri van de Velde, "Le paysan en peinture," *L'art moderne*, June 22, 1891, 61.

6. Mirbeau, "Camille Pissarro" (1904), 8. The same formulation appears in Octave Mirbeau, "Camille Pissarro," *Le Figaro*, February 1, 1892, 1.

7. "A conception entirely different from Millet's, an intimate sense of rural life, a clear vision of the local truth": Gustave Geffroy, "Camille Pissarro," *Exposition d'oeuvres récentes de Camille Pissarro* (Paris: Boussod, Valadon, 1890), 12.

8. Pissarro, letter to Lucien Pissarro, May 4, 1883, *Correspondance de Camille Pissarro*, 1:202.

9. Mirbeau, "Camille Pissarro" (1890), 84.

10. On an interpretive tension associated with Millet's art—between a generalized allusion to the fate of man (who must labor) and a more specific, politicized sense of the plight of contemporary rural workers in France—see Robert L. Herbert, "City vs. Country: The Rural Image in French Painting from Millet to Gauguin," *From Millet to Léger: Essays in Social History* (New Haven: Yale University Press, 2002), 32–34.

11. Charles Morice, "Le XXIe Salon des Indépendants," *Mercure de France* 54 (April 15, 1905): 553. Morice made a number of related observations: "Cézanne takes no more interest in a human face than in an apple"; and in the paintings of Henri-Edmond Cross, "the forms of the human figures and the vegetation mix and combine into the strangest unity" (552–53). For Morice, this leveling of representational subject matter indicated a moral problem, arising because of the contemporary emphasis on "pure technique," which was itself a sign of an unhealthy displacement of social and cultural values by scientific values (550).

12. Mirbeau noted that some critics dismissed Pissarro as merely the "Impressionist copy of Millet." Mirbeau, "Camille Pissarro" (1890), 84.

13. Octave Mirbeau, "L'Exposition Internationale de la rue de Sèze (II)" (1887), *Combats esthétiques*, ed. Pierre Michel and Jean-François Nivet, 2 vols. (Paris: Séguier, 1993), 1:335.

14. Pissarro, letter to Lucien Pissarro, December 30, 1886, *Correspondance de Camille Pissarro*, 2:92–93.

15. Pissarro, letter to Lucien Pissarro, July 30, 1886, *Correspondance de Camille Pissarro*, 2:64.

16. Pissarro, letter to Henri Van de Velde, March 27, 1896, *Correspondance de Camille Pissarro*, 4:180.

17. Paul Signac, *D'Eugène Delacroix au néo-impressionnisme*, ed. Françoise Cachin (Paris: Hermann, 1978 [1899]), 117. On "purity" in a related context, see Richard Shiff, "Risible Cézanne," in Eik Kahng, ed., *The Repeating Image in French Painting from David to Matisse* (Baltimore: Walters Art Museum, 2007), 127–71.

18. Morice, "Le XXIe Salon des Indépendants," 552–53. See also the quoted statements in note 11, above.

19. On this work, see Pissarro, letter to Claude Monet, 1879?, *Correspondance de Camille Pissarro*, 5:399–400, with historical notes by Bailly-Herzberg.

20. Mirbeau, "Camille Pissarro" (1904), 6. On the relationship of Mirbeau and Monet, see Pierre Michel and Jean-François Nivet, eds., *Octave Mirbeau.*

21. Pissarro, letter to Lucien Pissarro, January 10, 1887, *Correspondance de Camille Pissarro*, 2:101. See also Joachim Pissarro, "Pissarro's Neo-Impressionism," in Terence Maloon, ed., *Camille Pissarro* (Sydney: Art Gallery of New South Wales, 2005), 50–51. Around this time, Pissarro also appears to have been irritated by Monet's greater success in finding collectors for his work.

22. Paul Gauguin, letter to Camille Pissarro, c. July 10, 1884, in Victor Merlhès, ed., *Correspondance de Paul Gauguin, 1873–1888* (Paris: Fondation Singer-Polignac, 1984), 65.

23. Gauguin, letter to Emile Bernard, late November 1888, *Correspondance de Paul Gauguin, 1873–1888*, 284.

24. Pissarro, letter to Paul Durand-Ruel, November 6, 1886, *Correspondance de Camille Pissarro*, 2:75.

25. From the start, Gauguin's response to Cézanne was mocking as well as admiring; see his letter to Camille Pissarro, July 1881, *Correspondance de Paul Gauguin, 1873–1888*, 21.

26. Curiously, Pissarro's material mixture of grays from primary pigments—often his practice during the 1870s—anticipates his interest in Seurat's method of "optical" mixture, because both techniques were devised to generate chromatic complexity from a simple, "pure" foundation.

27. Paul Mantz, "Exposition des oeuvres des artistes indépendants," *Le temps*, April 23, 1881, 3; reprinted in Ruth Berson, ed., *The New Painting, Impressionism 1874–1886: Documentation*, 2 vols. (San Francisco: Fine Arts Museums of San Francisco, 1996), 1:357. Mantz was already on record complaining that the majority of the Impressionist painters were "mannerists posing as innocents" (Mantz, "L'exposition des peintres impressionnistes," *Le Temps*, April 22, 1977, 3; reprinted in Berson, *The New Painting*, 1:168).

28. Mirbeau, "Camille Pissarro" (1890), 84.

29. Wölfflin, born in 1864, was the age of Pissarro's eldest son Lucien, born in 1863.

30. Heinrich Wölfflin, *Principles of Art History*, trans. M. D. Hottinger (1915; repr., New York: Dover, 1950), 19–20, 22.

31. Wölfflin, 22: "Where the modelling of the surface of a cube has degenerated into separate blocks of light and dark . . . we stand . . . on Impressionist ground."

32. Wölfflin, 21.

33. For evidence of the primacy of emotional feeling among Pissarro's concerns, see his letters to Lucien Pissarro, April 13 and 20, 1891, *Correspondance de Camille Pissarro*, 3:63, 66; and the reply from Lucien, (early) May 1891, in Anne Thorold, ed., *The Letters of Lucien to Camille Pissarro, 1883–1903* (Cambridge: Cambridge University Press, 1993), 217.

Page references in **bold**
refer to illustrations

Anarchism, 5–6, 7, 9, 12, 13, 15, 16

Barbizon School, 2–3
Baroque era, 27
Brettell, Richard, 11, 13

Cassatt, Mary, 12
Cézanne, Paul, 3, 8, 12, 20, 21, 23, 26–27, 29
 House in the Country, 23, **24**
 Interior of a Forest, 23–24, **24**
Corot, Jean-Baptiste-Camille, 2, 6
 The Cart, Souvenir of Marcoussis, Near Montlhéry, 3, **3**
Courbet, Gustave, 3
Cubism, 27

Daumier, Honoré, 13
Degas, Edgar, 8, 9, 12
Dreyfus Affair, 11, 12
Durand-Ruel Gallery, exhibition catalogue, 15–16, **15**

École des Beaux-Arts, Paris, 2

Fénéon, Félix, 9

Gauguin, Paul, 22–23, 25, 29
 Landscape from Osny, 22, **22**

Haussmann, Baron Georges-Eugène, 2

Impressionists:
 anti-establishment views, 3
 artistic techniques of, 7, 11, 19, 22–24, 26, 28–29
 critical reactions to, 7–8, 19
 influence of Japanese prints on, 8
 movement cofounders, 22
 Neo-Impressionism, 8–10, 20
 sociopolitical views of, 12

Kropotkin, Prince Peter, 5

Le Jour et la Nuit, 8

Mantz, Paul, 26
Melbye, Fritz, 2
Millet, Jean-François, 16–18, 22, 24, 26
 Man with a Hoe, 17, **17**
Mirbeau, Octave, 15–16, 17, 18, 22, 23, 25, 26
Monet, Claude, 3, 12, 22, 25, 26–28
 Cap Martin, Near Menton, 23, **23**
Morice, Charles, 18, 21

Neo-Impressionists, 8–10, 20

Paris, Salons, 3
Petit, Rachel Manzano-Pomié, 2
Piette, Ludovic, 7
Pissarro, Camille:
 anarchist views, 5–6, 7, 9, 12, 13, 15, 16

anti-establishment views, 3, 5–6
artistic influences on, 3, 6, 8–10, 19
artistic methodology of, 5, 10–11, 18–20, 25–29
birth and family background, 2
critical reviews of work, 10, 18–19, 26
exhibitions of work, 15
influence on other artists, 22–23, 29
pathways as artistic motif of, 1, 11, 13
printmaking, 8–9
purity of work, 20–21, 23, 27, 28
sociopolitical ideology of, 5–7, 9, 11–13, 15
Pissarro, Camille, artworks by:
 Apple Trees in Bloom, Éragny, **74**
 The Artist's Palette with a Landscape, 21–22, **21**
 Avenue de l'Opéra series, 11, **12**, 12–13, 28, **71**
 Bazincourt, the Shepherd, **54**
 The Big Pear Tree at Montfoucault, **28**, 29; detail, **14**
 The Big Walnut Tree, Flooding, Sunlight Effect, Éragny, **64**
 Bouquet of Pink Peonies, 25, **25**
 The Brook at Montbuisson, Louveciennes, 6, **36**
 Carriages on the Boulevard Montmartre, **70**; detail, **ii-iii**
 Cart on a Road, Near Louveciennes, Winter, 5, **39**
 The Château de Busagny, Osny, **50**
 The Climbing Path, L'Hermitage, Pontoise, 8, **41**

The Delafolie Brickyard, Éragny, Sunset, **51**
Dockworkers at Rouen, **60**
Effect of Rain, **46**
Farm at Montfoucault, 7, **42**
Figures Conversing by a Country Road, **33**
Flood, Éragny, **66**
Girl in Field with Turkeys, **55**
The Haystack, Sunset, Éragny, 18, **69**
Hill at Pontoise, **38**
Houses at L'Hermitage, Pontoise, **40**
Houses on a Hill, Winter, Near Louveciennes, **37**
Inlet and Sailboat, 3, **32**
Kew Gardens, London, the Rhododendron Path, **63**
Landscape, **68**
Landscape at Éragny-sur-Epte, 11, **57**
Landscape at Osny, View of the Farm, **48–49**
La Roche-Guyon, **31**
Lordship Lane Station, Dulwich, 4, **4**
The Louvre and the Carrousel Garden, Sunlight, Afternoon, **73**
The Market on the Grande-Rue, Gisors, **53**
Orchard at Saint-Ouen-l'Aumône in Winter, 26, **45**
Path Leading to Osny, 22, **22**
Peasants' Houses, Éragny, 10, **10**
Peasants in the Fields, Éragny, 15, **16**
Peasant Woman Herding Cows, **68**
Peasant Woman in a Cabbage Patch, Éragny, 18, **75**

Peasant Woman Knitting (Study for a Fan), **54**

Peasant Women Shifting Straw, Montfoucault, 7, **43**

Picking Peas, **58**

Piette's House at Montfoucault, Snow Effect, 25, **25**

Place de la République at Rouen, with Tramway, 10, **61**

Place du Théâtre Français, Paris: Rain, 11–12, **12**

Place du Théâtre-Français and the Avenue de l'Opéra, Hazy Weather, 11, 28, **71**

Ploughing, Bérelles, **34**

Ploughing at Éragny, 19, 20, 27, **56**

The Pont Boieldieu at Rouen, Effect of Mist, **67**

The Pont-Royal, Bright Cloudy Weather (Fourth Series), 13, **77**

The Port of Rouen, **60**

Port of Rouen: Unloading Wood, 18, **18**

The Railway Crossing at Les Pâtis, Near Pontoise, 1, **1**

The River Oise, Near Pontoise, 4, **4**

Saint Anne's Church in Kew, London, **62**

Sous bois, **35**; detail, **x**

Sunlight on the Road, Pontoise, 18, **18**

Turpitudes Sociales series, 13, **13**

Two Women in a Garden, **59**

View of Bazincourt, Flood, **65**

View of Pontoise, **46**

The Wharves, Saint-Sever, Rouen, **72**

Winter at Montfoucault, Man Riding a Horse, 7, **7**, **44**

Woman at a Well, 18, **52**

The Woods at L'Hermitage, Pontoise, (also called *Wooded Landscape at L'Hermitage, Pontoise*) 8, **8**, **47**

Pissarro, Frédéric, 2

Pissarro, Joachim, 9, 11

Pissarro, Lucien:

Cover of Durand-Ruel Gallery Retrospective Exhibition Catalogue for Camille Pissarro, 15, **15**

father's letters to, 4, 6–7, 9, 10, 12

as printmaker, 9

Pointillism, 9, 11, 19–20, 23

Primitivism, 23

Proudhon, Pierre-Joseph, 5

Renaissance, 27

Renoir, Pierre-Auguste, 3, 12

Seurat, Georges, 9, 22

Woman with a Monkey (Study for "A Sunday Afternoon on the Island of La Grande Jatte"), 19–20, **20**

Shapiro, Barbara Stern, 8

Shiff, Richard, 7

Signac, Paul, 9, 20, 23

Sisley, Alfred, 3

Universal Exposition, Paris, 2, 3

Vellay, Julie, 6–7

Wölfflin, Heinrich, *Principles of Art History*, 27

Zola, Émile, 3, 4, 12

Boldface numerals refer to page numbers.

ABBREVIATIONS

AMFA Achim Moeller Fine Art, Ltd., New York

CAI The Sterling and Francine Clark Art Institute, Williamstown, Massachusetts

MFA Museum of Fine Arts, Boston

MMA The Metropolitan Museum of Art, New York

NYPL The New York Public Library

TJM The Jewish Museum, New York

WIP The Wildenstein Institute, Paris

FRONT COVER: © 2007 TJM, photograph by Wit McKay.

FRONTMATTER: **i** NYPL. **ii–iii** AMFA.

BACK COVER: © 2007 TJM, photograph by Richard Goodbody.

LEVITOV ESSAY: **x** © The Hyde Collection, Glens Falls, New York, photograph by Steven Sloman. **3** © Réunion des Musées Nationaux/Art Resource, New York, photograph by Jean Schormans. **4** © 1995 CAI (left), Courtauld Institute of Art (right). **7** WIP. **8** Photograph © 2007 MFA (top and bottom). **10** Art Gallery of New South Wales, Sydney, Australia. **12** Minneapolis Institute of Arts. **13** © Denver Art Museum.

SHIFF ESSAY: **14** © 2007 Kunsthaus Zürich. All rights reserved. **15** From Joachim Pissarro and Claire Durand-Ruel Snollaerts, *Pissarro: Critical Catalogue of Paintings* (Milan and Paris: Skira/Wildenstein Institute, 2005), vol. 1, p. 51. **16** Photograph © Albright-Knox Art Gallery. **17** The J. Paul Getty Museum, Los Angeles. **18** Photograph © 2007 MFA (left), © 1989 CAI (right). **20** Smith College Museum of Art, Northampton, Massachusetts. **21** © 1990 CAI. **22** © Réunion des Musées Nationaux/Art Resource,

New York, photograph by René-Gabriel Ojéda (left), New Carlsberg Glyptotek, Copenhagen, Denmark, photograph by Ole Haupt (right). **23** Photograph © 2007 MFA. **24** © Wadsworth Atheneum Museum of Art, Hartford, Connecticut (left), Art Gallery of Ontario, Toronto (right). **25** © Fitzwilliam Museum, University of Cambridge, UK/The Bridgeman Art Library (top), © Ashmolean Museum, University of Oxford, UK (bottom). **28** © 2007 Kunsthaus Zürich. All rights reserved.

PLATES: **31** Courtesy of Stern Pissarro Gallery, London. **32–33** Courtesy of Michael Connors Antiques, New York. **34** © 2007 TJM, photograph by Richard Goodbody. **35** © The Hyde Collection, Glens Falls, New York, photograph by Steven Sloman. **36** WIP. **38** NYPL. **39** WIP. **40** © 2007 TJM, photograph by Richard Goodbody. **41** Brooklyn Museum. **42** Photograph © Albright-Knox Art Gallery. **43–44** WIP. **45** © Christie's Image Ltd., 2007. **46** NYPL (top and bottom). **47** Photograph © MMA. **48–49** © 2007 TJM, photograph by Richard Goodbody. **50** Courtesy of The Art Collection, Inc., Great Neck, New York. **51** WIP. **52** Photograph ©2007 MMA. **53** WIP. **54** Courtesy of Stern Pissarro Gallery, London (top). **55** Brooklyn Museum. **56** Courtesy of Barbara Divver Fine Art, New York. **57** The Pierpont Morgan Library, New York, photograph by Joseph Zehavi. **58** © 2007 TJM, photograph by Richard Goodbody. **59** Photograph ©1999 MMA. **60** NYPL (top), Photograph © 2007 MMA (bottom). **61** NYPL. **62** AMFA. **64** WIP. **65** Courtesy of The Art Collection, Inc., Great Neck, New York. **66** WIP. **67** © 2007 TJM, photograph by Richard Goodbody. **68** NYPL (top), © 2007 TJM, photograph by Richard Goodbody (bottom). **70** AMFA. **71–72** WIP. **73** Courtesy of Acquavella Galleries, Inc. **74** AMFA. **75** WIP. **77** © 2007 TJM, photograph by Wit McKay.